IMAGES
of America

PLEASANTVILLE

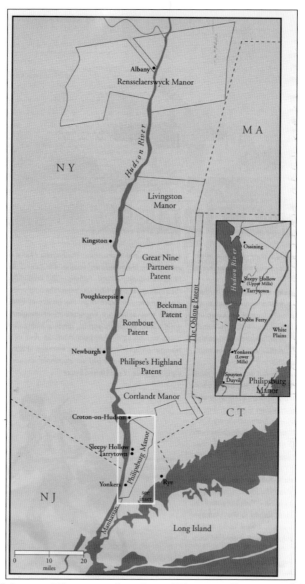

HUDSON VALLEY MANORS. The original settlers of Pleasantville migrated from the Philipsburg Manor, Upper Mills in Sleepy Hollow in 1695. The Hudson River allowed the Upper Mills to evolve into a vibrant milling, trading, and agricultural center with easy access to the giant port of New York. Adolph Philipse was no farmer, and he did not live at Philipsburg Manor. He was an international merchant, a veteran of British colonial politics and government, a bachelor involved in Manhattan's social scene, and one of the wealthiest residents of New York City. (Courtesy of the Historic Hudson Valley.)

ON THE COVER: The 1947 Memorial Day Parade celebrated Pleasantville's 50th anniversary. Leading the parade is the Pioneer Engine Company (founded on December 10, 1894), followed by the Daniel P. Hays Hose Company (founded on November 2, 1901). The Manville Road procession features the Rome Theatre on the right and the original Pleasantville Ford dealership on the far left. (Courtesy of Phebe Holden Washburn.)

IMAGES
of America

PLEASANTVILLE

Bert Ruiz

ARCADIA
PUBLISHING

Copyright © 2013 by Bert Ruiz
ISBN 978-0-7385-9759-1

Published by Arcadia Publishing
Charleston, South Carolina

Printed in the United States of America

Library of Congress Control Number: 2012938754

For all general information, please contact Arcadia Publishing:
Telephone 843-853-2070
Fax 843-853-0044
E-mail sales@arcadiapublishing.com
For customer service and orders:
Toll-Free 1-888-313-2665

Visit us on the Internet at www.arcadiapublishing.com

To Adrienne
Semper Fidelis

CONTENTS

The Village 🍎 Bookstore

Select Books
Distinctive Cards
Unique Gifts
Children's Books
Special Orders
Free Gift Wrapping
Agate Bookends
Journals
Book Group Discounts
School Orders
Cook Books
Bookmarks
Out-of-Print
Reference Books
Gift Certificates
...and more!

Ten Washington Avenue
Pleasantville, NY 10570
914.769.8322
staff@pleasantvillebooks.com

ACKNOWLEDGMENTS

The acknowledgments page of every book is always a sticky thicket. So many people have played a hand in the production of this publication that it is virtually impossible to name them all. Certainly, some have contributed more than others, so it is proper to start at the very top and identify those individuals that served as the cathedral of knowledge. First and foremost is Carsten Johnson, the village of Pleasantville curator, who has been a friend since 1972 and who generously shared his time and wealth of information in a selfless manner. Next would be John Crandall, the retired village historian who provided the careful guidance that helped me find the original name of Pleasantville, "Bever Meddow." These two gentlemen are guardians of Pleasantville's rich history and served as trusted elders always sharing their knowledge with a steadfast spirit of encouragement.

Martha Mesiti, the highly skilled reference librarian at the Mount Pleasant Library is a credit to the community and to this body of work. As is Fred G. Higham, the retired president of Higham Press, which operated in Pleasantville for nearly half a century and who generously shared his private collection of local archives. Patrick Raftery, president of the Mount Pleasant Historical Society and librarian at the Westchester County Historical Library and Research Center also contributed to the manuscript. Dianne Ripley is critical to the success of this book as well as Moose Schuessler and the dozens of other families that shared photographs. In particular, the Southern Italian families in the Flats blessed me with countless and priceless bits of information that allowed me to weave this wonderful tapestry of history. Unless otherwise noted, all images appear courtesy of the Mount Pleasant Historical Society. I would be remiss if I did not thank Adrienne, my significant other, my four sons, Bert, Justin, Jack, and Jamie, and my two grandsons, Austin and Aiden, for their love and compassion. Lastly, I want to express my sincere gratitude to young Caitrin Cunningham and Laura Saylor, my supremely talented editors at Arcadia Publishing, for their prompt and professional attention.

INTRODUCTION

The research and writing of this book has clearly been an uplifting experience. On some days towards the completion, I wanted to rid myself of the manuscript just as an expectant mother can tire of pregnancy in the last month. On other days, I could not let go—there were always changes to be made, more people to talk to, more archives to research, and fresh photographs to examine, and quite frankly, I was just having way too much fun interviewing, researching, writing, and rewriting. The village of Pleasantville is truly a very special community and its history is absolutely fascinating. To this end, I have fallen in love with the people and places that make up the rich social fabric of this village. I grew up in Mount Vernon and came to Pleasantville fresh out of the jungles of Vietnam where I spent two tours as a combat Marine. I did my undergraduate work at Pace on the GI Bill and got my first job out of the Marines as a freshman working for Harry Foley, the dynamic owner of Foley's Club Lounge.

Working at Foley's paid two dividends. It allowed me to work in the shadow of Harry, a native son of Pleasantville who was one of the most generous and popular individuals I have ever met in my life. Harry's network of connections was immense and each and every one of his friends treated me like his little brother. It was an acceptance that truly cannot be defined. It was an experience that helped me become who I am today. Overtime I understood the civic pride, the great tradition of charity in Pleasantville, and like those before me I too became involved in the great legacy of community involvement and compassion. To a certain decree, the Pleasantville tradition is similar to what we had in the Marine Corps, "to watch each other's back." I never had this in Mount Vernon. However the big difference was that the Marine Corps was a tough brotherhood and Pleasantville was nurturing and I warmed in its embrace. It did not take me long to know that this is where I wanted to lay down my roots and raise my family as I commuted to Wall Street. The second dividend of working at Foley's is that I met an entire generation of young Pleasantville High School graduates who treated me like one of their own. I want to add a special thanks to the class of 1974. The combination of Harry's local contacts and the great generation of kids that frequented Foley's during my four years of undergraduate work and two years of grad school at New York University was pure gold. I feel free to get into the historical introduction now that you know something about the author, a trained journalist who considers it an honor to research and write Pleasantville's wonderful history. The one liberty I took with the manuscript is that I crammed as many photographs in the book as possible. Consequently, the early history of Pleasantville is not examined in great detail. Hence, I will use the introduction to explain the early history of Pleasantville and allow the subsequent chapters to advance the historical narrative.

In the beginning, nature blessed the area now known as Pleasantville with an abundance of water, game, fish, wild vegetables, nuts, and herbs for food and medicine. Peaceful Native Americans were the first inhabitants of the region. The fertile Hudson River Valleys provided the early tribes with excellent growing conditions for corn and other crops. The Native Americans

were excellent hunters and possessed an intimate knowledge of all forms of baits for the diverse fishing in the region. The Native Americans also learned to navigate the mighty Hudson River to travel great distances. The ancient trail from Pleasantville to the Hudson River was called "Succabonk," now we call it Bedford Road.

On September 12, 1609, Henry Hudson and his Dutch crew sailed the vessel *Half-Moon* 315 miles from the mouth of the river named for him to its beginning near the city of Troy. They were searching for a passageway to the Orient. Instead, they discovered a deep waterway surrounded by a land rich in furs. In time, traders would come to exchange new wares with the Native Americans. Eventually, the Philipsburg Manor, Upper Mills trading post was built to accommodate the flourishing trade in furs and to nurture grain production. Initially, enslaved Africans of diverse backgrounds worked on the manor and tenant families from several European cultures farmed the nearby land. On occasion, laborers would be hired to work alongside tenants on the farms.

Isaac See (Sie), a French Huguenot who first settled in the Harlem Heights then relocated to Staten Island before deciding on the Manor, was the first to move his family from the safe confines of the Upper Mills. It was around 1695. Local historians Mildred E. Struble and Philip Field Horne have long asserted the See family settled at the four corners in Thornwood. However, a close examination of See family archives by Pleasantville curator Carsten Johnson puts the first family home directly across from the Cottage School on Broadway, close to a brook which existed on Country Club Lane in Pleasantville. The farm extended westward to Sunnyside Avenue, south to the Saw Mill River (Nanegeeken), north to Bedford Road, and east almost to Ashland Avenue. The See family was prominent in Pleasantville affairs since inception. In time, the Leggett, Ackerman, Haight, Pierce, Matthews, and Foster families would follow the See's into Pleasantville. However, many of the farms were over 100 acres and would often stretch into Thornwood . . . and in some cases all the way to Hawthorne. Life outside the manor was not harsh for the tenant farmers. The Upper Mills would grow to be a powerful river trading post and the farmers would find favorable prices for their grain. Moreover, they would be able to purchase needed supplies, utensils, and agricultural tools essential to survival outside the Manor. Nevertheless, none of the families in Pleasantville were freeholders (owned land) and consequently none of them had the right to vote under English rule. Historically, the first recorded name for Pleasantville was "Bever Meddow" (Beaver Meadow) according to Samuel and James Dean's 1763 archives of local meetings. In fact, Pleasantville was not called Clark's Corners until 1795.

When the American War of Independence started, most of the tenant farmers in the Lower Mills of Yonkers remained loyal to the British crown. However, families in the Upper Mills were primarily patriots. The war brought enormous hardship to the families in Pleasantville. Some families pulled up roots and sought the protection of the Continental Army in the Highlands. Much of Westchester County was in "Neutral Ground," a no-man's land of lawlessness that left the civilian community terrorized by cowboys, loyalist forces, and "Skinners" patriot's parties that foraged for supplies and livestock.

Frederick Philipse III was a fourth-generation American and the last Lord of the Philipsburg Manor, Upper Mills in Sleepy Hollow. He was a member of the colonial Assembly and was considered such a dangerous Tory during the Revolutionary War that he was among those condemned to death by New York State in 1779. After the war, the New York Office of Forfeiture confiscated Philipsburg Manor and auctioned off the land to returning veterans and local patriot farmers.

One

THE ORIGINAL PEOPLE

Peaceful Native Americans were the first inhabitants of Pleasantville. They were known as the Weckquaeskecks. The word Weckquaeskeck is believed to mean, "The open land around our home." They sometimes referred to themselves as Lenni-Lenape or "Original People." Early historians reported they were profound in their common sense simplicity, "they did not recite poetry . . . they lived it." The original people were immensely spiritual with a deep reverence for the magnificence of nature. Moreover, the Weckquaeskecks said they had no word for time. The original people seldom lost their way; they expertly navigated the waterways and ancient trails for hundreds of miles. To this end, the ancient Indian trail in Pleasantville was named, "Succabonk," currently known as Bedford Road.

The subsequent arrival of the Dutch and the establishment of New Amsterdam in New York Harbor coincided within years with that of other New World settlements as Plymouth and Jamestown. New Amsterdam differed than the other settlements because land expansion through farming was not the overriding priority. Consequently, the Dutch set up a series of patroonships, or large elite manors to facilitate trade, and New Amsterdam was quickly dwarfed in size by the flow of free land farmers in Massachusetts and Virginia. Ultimately, the greatest trading nation on earth at that time fell in love with the deep tidal Hudson River that permitted ocean-going vessels to penetrate a hundred miles beyond the Appalachian barrier to rich fur-bearing lands. To the Dutch, colonization was secondary and trade powered its economic engine.

In 1695, Isaac and Esther See (French Huguenots), along with their son Isaac and his wife, Maria, were the first tenant family to leave the Philipsburg Manor Upper Mills and settle in Pleasantville. They lived among Indians and used the ancient Indian trail to and from the Manor for trade and weekly church services. Their farmhouse was built off Broadway near a brook, which today is Country Club Lane. The farm was 169 acres and stretched into Mount Pleasant. The See's would be involved in Pleasantville's growth for centuries. Today, Pleasantville resident Dianne Ripley can directly trace her family roots to Isaac and Esther See.

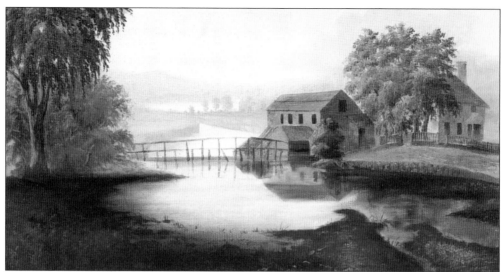

SCENIC UPPER MILLS. For centuries before the arrival of the Dutch, the Wekquaesgeeks farmed, hunted, and fished near the confluence of the Hudson and Pocantico Rivers. Between 1680 and 1750, a surprisingly diverse group of people converged at the Upper Mills of Philipsburg Manor. The people who lived and traded here were brought together by the varied business ventures of Frederick Philipse (1692–1702) and his son, Adolph (1665–1750). (Courtesy of the Historic Hudson Valley.)

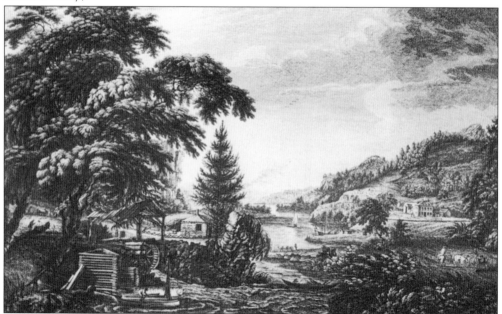

SCENIC HUDSON RIVER VALLEY. A passion for trade enticed the earliest Dutch settlers to New Netherland, later called New York. Every member of the Philipse family took the oath of allegiance to the King of England, Charles II, when the British took over New York in 1664. However, the tenant farmers of Upper Mills were primarily patriots. In 1695, Isaac and Esther See, French Huguenots, became the first tenant farmers to settle in Pleasantville. The See farmhouse was off Broadway close to a brook which today is near Country Club Lane. (Courtesy of the Historic Hudson Valley.)

FREDERICK PHILIPSE. On October 22, 1779, Frederick Philipse, third Lord of the Manor of Philipsburg, was one of 59 Loyalists attainted of treason by the New York State Legislature. For Philipse, this meant that his large estate in Westchester County and all of his other earthly possessions were forfeited to the state and that Philipse himself was condemned to death without trial if apprehended within the borders of New York. (Courtesy of the Historic Hudson Valley.)

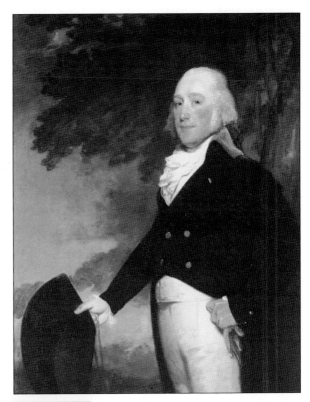

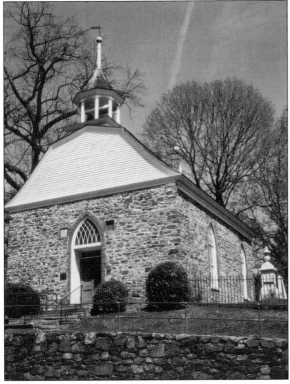

THE OLD DUTCH CHURCH. The Old Dutch Church was built in 1699 by Frederick Philipse and his second wife, Catherine Van Cortlandt. Standing across from Philipsburg Manor on the east side of Route 9, is one of the oldest active houses it is of worship in the United States and was originally part of the manor. Isaac See's son Jacobus would become Deacon of the Old Dutch Church in 1701. (Courtesy of the Historic Hudson Valley.)

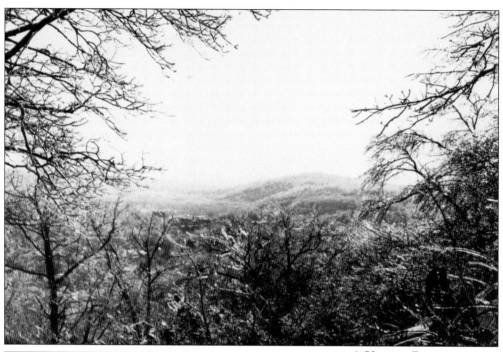

A VIEW OF PLEASANTVILLE IN WINTER. Pictured is a winter view of Pleasantville from the summit of Flag Hill around 1970. In the distance is the ancient Indian trail named Succabonk, currently known as Bedford Road. (Courtesy of Fred Higham Jr.)

LETTER FROM ISAAC SEE TO ABLE SEE, 1851. This September 17, 1851, letter was mailed from Elmira, New York, by Isaac See to Abel See in Pleasantville. Postage was only 3¢. (Courtesy of Dianne Ripley.)

STEPHEN BRUNDAGE. Stephen Brundage was born in 1818. His daughter, Elizabeth, would marry Sylvester See, great-grandson of Isaac and Mary See, the first settlers of Pleasantville. This photograph is from around 1890. (Courtesy of Dianne Ripley.)

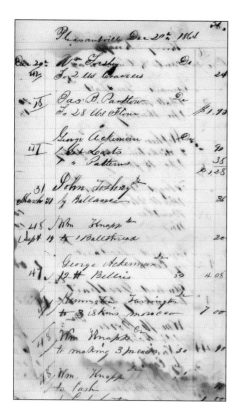

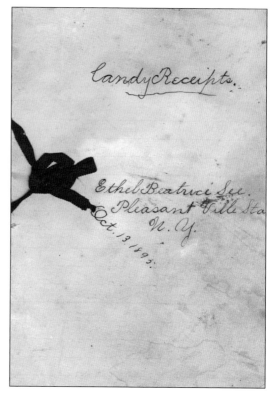

PEANUT CANDY RECIPE. Ethel Beatrice See's recipe for peanut crisp and molasses taffy is a clear indication that the educational system of the day was only adequate. (Courtesy of Dianne Ripley.)

Peanut Chrisp.

2 cups sugar to 1½ cups chopped peanuts.
Melt the sugar till it runs then stir in the peanuts.
Pour in buttered pan and set away to cool.

Molasses Taffy.
1 cup molasses, 1 cup sugar a peice of butter the size of an egg.
Boil hard, test in cold water when brittle, pour in

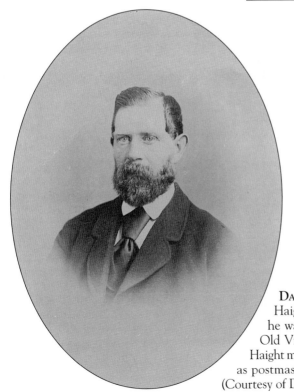

DAVID HAIGHT. This photograph of David Haight was taken on August 14, 1889, when he was formally appointed postmaster of the Old Village Post Office at 200 Bedford Road. Haight married into the See family and was replaced as postmaster on June 21, 1893, by Elliott H. See. (Courtesy of Dianne Ripley.)

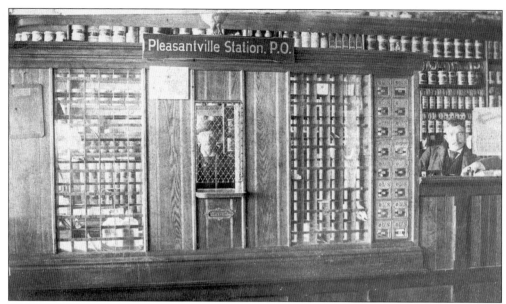

POST OFFICE. The Old Village Pleasantville Post Office at 200 Bedford Road was the communication center for many Mount Pleasant residents. (Courtesy of Pleasantville Village Archives.)

ALBERT SEE. Albert See, photographed around 1910, was general manager of Cornell's Fuel and Lumber Company. Like most men of his generation, he was active in village affairs and helped incorporate the Pleasantville Library Association. Albert See also loved automobiles. He reportedly had the first automobile in Pleasantville. See (at the wheel) drives his newer model on Bedford Road. (Courtesy of Dianne Ripley.)

ETHEL SEE. Ethel See was Albert See's daughter. She married Ernest Huntington Ripley from Geneseo, New York. Ripley originally was a teacher, then went into the real estate business. (Courtesy of Dianne Ripley.)

ALBERT AND MARJORIE RIPLEY. Albert and Ethel See had two children, a daughter, Marjorie, and a son, Albert Jr., shown in this photograph. Albert Ripley Jr. would marry Elizabeth Gibbs in 1945. Their daughter Dianne (Pleasantville High School class of 1970) would eventually assume the responsibilities of family historian and collected the valuable See archives. (Courtesy of Dianne Ripley.)

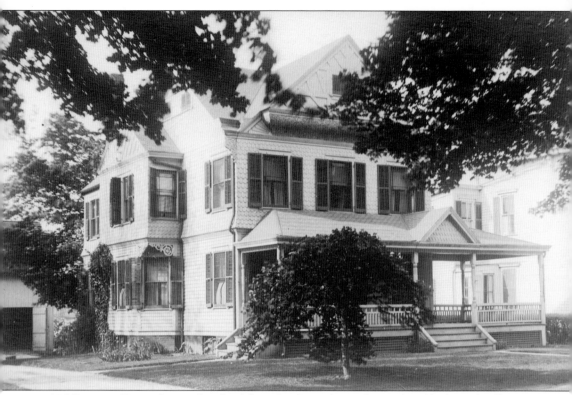

405 BEDFORD ROAD. Pictured is the Albert See home located at 405 Bedford Road. Albert See selected this Queen Anne–style home from *Shoppell's Modern Houses* and used the lumber from Cornell Fuel and Lumber to erect the house around 1900. It was the childhood home of Albert Jr. and Marjorie Ripley. (Courtesy of Dianne Ripley.)

Two

BIRTH OF A NATION

Pleasantville paid a heavy price during the War of Independence. Military historians will never compare it to the colossal catastrophe of the Fall of Rome, or to the carnage of the American Civil War. However, during the American Revolution, Westchester County, New York, suffered more casualties and destruction of property than any other county in the 13 colonies that had declared nationhood in 1776. At the war's conclusion, Westchester County was devastated and nearly depopulated.

The reason for the violence and pillage was simply because Pleasantville was in no-man's land or "Neutral Ground," with British forces entrenched south in New York City and the Continental Army securing control of the upper Hudson River in the highlands. The absence of law and order led to countless raids where valuable livestock, produce, clothes, bedding, and household equipment were stolen. In many cases, the terrorizing attacks left civilian families begging not to be left naked and without food.

Westchester County had become notorious for marauder plundering by the British, Hessian mercenaries, Tories, patriots, and criminal opportunists who took advantage of the anarchy. A confused and volatile mix of greed, revenge, civil war, guerrilla warfare, and sheer banditry produced many of the outrages and atrocities, according to historians. In fact, the hardship for Westchester and Pleasantville began before 1776 and did not end until the departure of the last British troops from New York City on November 25, 1783.

Two notable patriots who often stayed or passed through Clark's Corners (Pleasantville) on separate occasions and sought to protect the civilian population were 22-year-old Lt. Col. Aaron Burr and 26-year-old Maj. William Hull. The two officers were assigned to the lines, the thin outposts stretching from Tarrytown to the Byram River in Armonk. The officers attempted to combat the lawlessness by rigorously enforcing martial law and organizing patrols of local militia to regularly report and counter the movement of foraging parties. Ultimately, the same local militia patrols structured by Burr and Hull would be responsible for the critical capture of British spy Maj. John Andre.

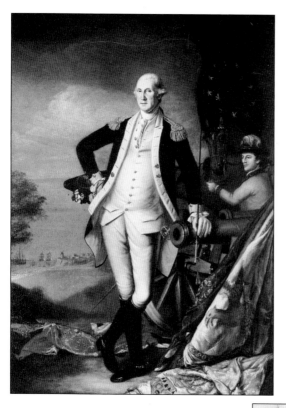

George Washington. Pleasantville played a key role in the nation's war of independence. It was 1780; the period was the darkest of the war, because after four years of fighting, victory seemed as far off as ever. Consequently, the capture of British spy Maj. John Andre by local militia and the destruction of Benedict Arnold's treason allowed Gen. George Washington and the nation's Continental Army to turn the tide of war and ultimately attain victory.

THE TALE OF ISAAC SEE Jr.
My
Great, Great, Great, Great, Great, Great
Grandfather

The descendants of Isaac See Jr. know very little of his services as a Revolutionary soldier, but have not forgotten that incident in his soldierly career about which I will tell you.
He was a member of Capt. Requa's Company and at another time of Capt. Martling's Company, and also Colonel Hammond's Westchester County Regiment of Militia. When a party of soldiers was made up at North Salem on the 22nd day of September, 1780, to come down to Tarrytown to watch the roads for parties taking cattle to the British, Isaac See Jr. was one of the seven. It was a time of doubt and despair, that summer of 1780, with Washington's troops camped at Peekskill and in the Highlands, battered and ragged from fighting a losing war. Hope was pinned on West Point to hold the British from command of the Hudson River. This was the dark picture for the Americans when Major Andre of the New York staff of British General Clinton met with General Arnold, American commander at West Point, on September 22nd to arrange for Arnold's betrayal of West Point. After the meeting, Andre rode alone on horseback, seeking his way down the Westchester shore of the Hudson to the safety of the British lines. On the morning of September 23rd he rode over Buttermilk Hill from Mount Pleasant down in-

Tale of Isaac See Jr. One. The capture of British spy Maj. John Andre on September 23, 1780, gave birth to a nation. The seven militias split up . . . with Yerks, See, Abraham Williams, and Romer taking post on an obscure road near Old Post Road in Tarrytown, known to be frequented by cattle thieves moving livestock to the British in New York City. Paulding, Van Wart, and David Williams were nearby but east of them off Bedford Road near Hardscrabble Road. (Courtesy of Dianne Ripley.)

TALE OF ISAAC SEE JR. TWO. Van Wart was the lookout while Paulding and Williams played cards. Paulding was the only one of the three who could read. Andre showed up just before 11:00 a.m., and they immediately knew he was not a local. Paulding wore a Hessian's red coat, which had helped him in an escape from the New York prisons only four day earlier. It misled Andre, who inexplicably was outwitted by the youths; he was ordered to dismount and the incriminating papers were found. (Courtesy of Dianne Ripley.)

to Tarrytown. Without his British uniform, he seemed to be a journeying gentleman armed with a pass from Arnold. Hidden in Andre's boots were the plans for the surrender of West Point and also plans for the kidnapping of General Washington. Into the farming region, harried and ruined from the war, he made his way down old Bedford Road to the Post Road in Tarrytown. The party of soldiers to which Isaac See Jr. was attached was stationed along this road waiting for cattle thieves, when they saw Andre stopped along the road poring over a map as though lost. The soldiers, not trusting anyone, had Andre dismount from his horse, and searched him, finding the papers hidden in his boots. Andre offered the boys any sum of money they wanted for his freedom, but they decided to take their captive to Lt. Col. John Jameson of the Westchester Militia. The full story of Arnold's planned betrayal of his country was revealed. Andre was hanged on October 2nd, 1780.

References:
Genealogical record of the See family written by Daniel VanTassell.

Reporter Dispatch - a White Plains newspaper story written by Maureen McKernan.

(This story was written by John Tallman Jr. for school work)

BEDFORD ROAD. Pleasantville grew fast. This photograph is of the corner of Bedford and Locust Roads around 1900. Note the now demolished Opperman Pond icehouse on the immediate left. Pleasantville residents would regularly have blocks of ice delivered by horse and carriage for use in kitchen iceboxes. (Courtesy of Pleasantville Village Archives.)

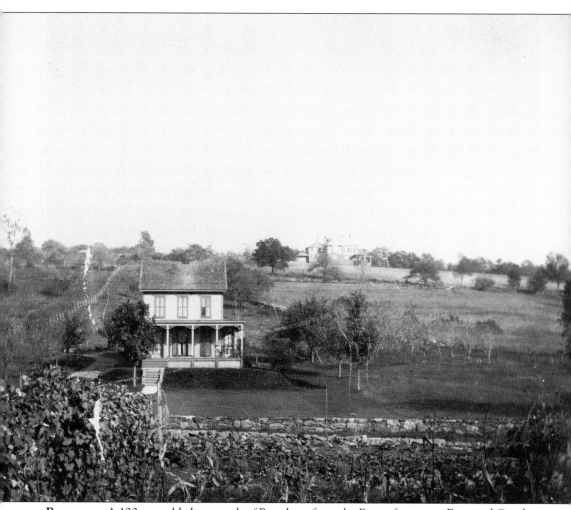

BROADWAY. A 100-year-old photograph of Broadway from the Pierce farm, now Foxwood Condos. Hillcrest, the magnificent home of Daniel P. Hays, is off in the distance. (Courtesy of Pleasantville Village archives.)

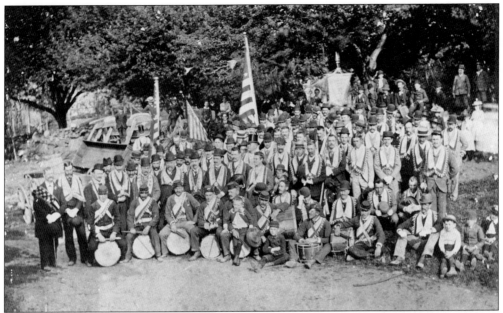

FOURTH OF JULY. This c. 1880 photograph is of the colorful Fourth of July celebration with Civil War veterans and children at the strawberry field, now the site of Pleasantville High School. (Courtesy of Pleasantville Village Archives.)

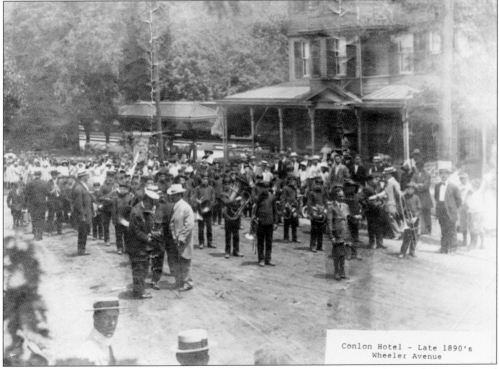

Conlon Hotel – Late 1890's
Wheeler Avenue

WHEELER AVENUE PARADE. Pictured is another Pleasantville Fourth of July parade from around 1890, but this is on Wheeler Avenue in front of the popular Conlon Hotel, with the train station in the background. (Courtesy of Pleasantville Village Archives)

23

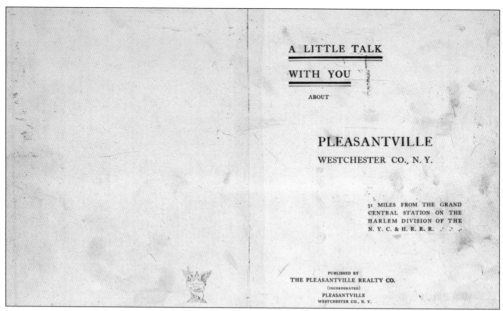

A LITTLE TALK WITH YOU. This extremely rare 1903 publication of *A Little Talk With You* by the Pleasantville Realty Company (PRC) was created to attract wealthy New Yorkers. It displayed the finest homes of the village. The president was Daniel P. Hays, the vice president was Fred B. Haviland, the treasurer was S. Wood Cornell, and the secretary was W.S. Moore. (Courtesy of Fred Higham Jr.)

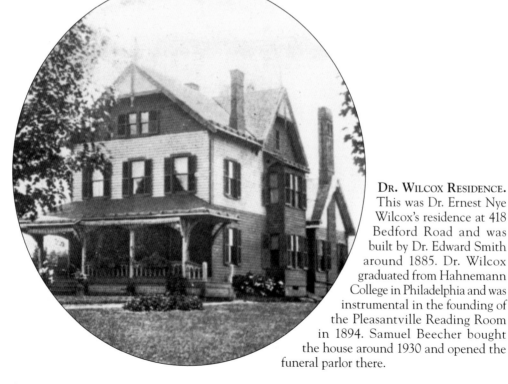

DR. WILCOX RESIDENCE. This was Dr. Ernest Nye Wilcox's residence at 418 Bedford Road and was built by Dr. Edward Smith around 1885. Dr. Wilcox graduated from Hahnemann College in Philadelphia and was instrumental in the founding of the Pleasantville Reading Room in 1894. Samuel Beecher bought the house around 1930 and opened the funeral parlor there.

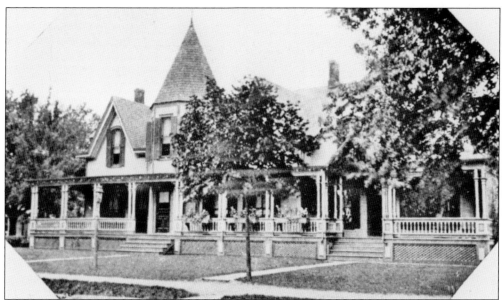

GEORGE WASHBURNE RESIDENCE. The George Washburne residence at 415 Bedford Road is seen here. It was built by Marmaduke Forster in 1786 and was owned by Henry Hobby in 1828. Nelson Mabee purchased the home in 1870 and remodeled it with three gables for a temperance hotel. Purchased by George Washburne in 1893, he added the projecting tower and pyramidal roof. The architect was S. Wood Cornell. The trabeated architecture contrasted with the three-story mansard homes lining Bedford Road.

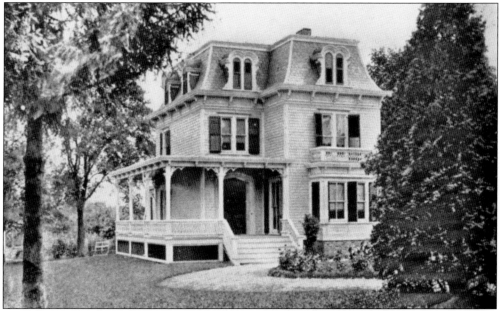

SILAS THAYER WILD RESIDENCE. Seen here is Silas Thayer Wild's residence at 266 Bedford Road, not to be confused with the Hunter House at 334 Bedford Road. It was one of the earliest Mansard-roofed houses in Pleasantville. Wild, a descendant of Priscilla and John Alden, came to the area in 1858 with his father, Alden Wild, who bought Moses Pierce's farm. The Wild family developed the marble quarry in Thornwood.

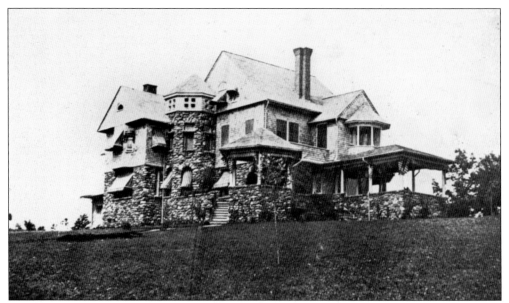

DANIEL P. HAYS'S HILLCREST RESIDENCE. Hillcrest, with the exception of the Manville mansion, was arguably the finest home ever built in Pleasantville. It was the residence of Daniel P. Hays, located on Hays Hill Road and the end of Greenmeadow Road. He was a successful lawyer in New York and christened his home "Hillcrest." Hays was active in the incorporation of the village, the building of the high school, and was president (mayor) of Pleasantville from 1898 to 1905.

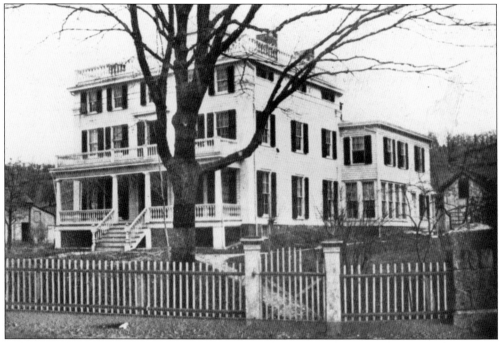

JOSEPH LEGGETT RESIDENCE. The Hays Hotel was built in 1848 and purchased by Joseph Leggett in 1870 as his primary residence. Leggett was the Town of Mount Pleasant supervisor. After his death, heirs lived there until it was rented out as the Pollyanna Inn during the 1910s. It was demolished in 1923. It is currently the site of Michael's Tavern in the old village.

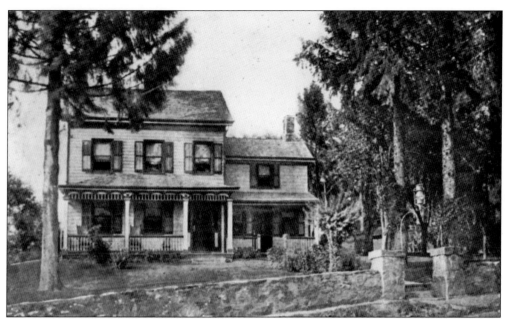

JAMES P. MOORE RESIDENCE. The James E. Moore residence was on the corner of Pleasantville Road and Cooley Street (the site of the gas station). This house was built by William Hammond in the 1830s in the area called Goose Hollow. The Moore family moved in around 1858. Moore was an inspector with the New York Customs House in New York City. He was active in the incorporation of the village, the high school, and served as village justice.

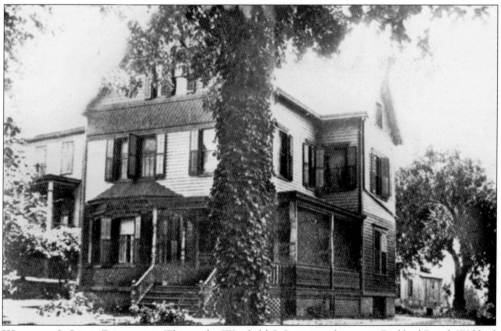

WINFIELD S. LANE RESIDENCE. This is the Winfield S. Lane residence on Bedford Road. Wilfred opened Lane Brothers Store with his brothers Benjamin and Mortimer. The brothers also published a local newspaper. This home was located in the parking lot of the JPMorgan and Chase Bank on Bedford Road.

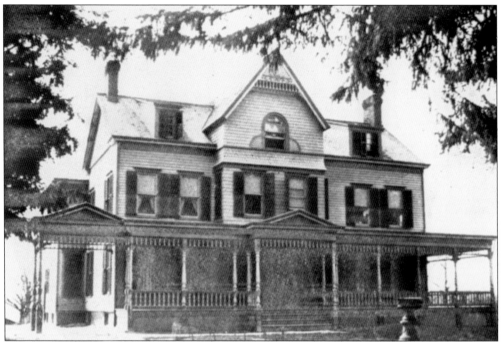

CHARLES A. ROBINSON RESIDENCE. This 1903 residence belonged to Charles A. Robinson and was located on the corner of Church Street and Robbins Road. It was built as a farmhouse by John Palmer in 1855 and purchased by George B. Robbins in 1891.

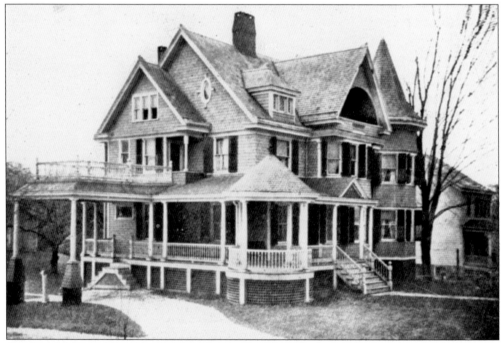

CHARLES M. PURDY RESIDENCE. The 1903 residence of Charles M. Purdy at 224 Bedford Road is seen here. This impressive residence was purchased by John Robb Christie in 1910. He sold nearby small building lots to his employees at Railway Express and called it Christie Court.

GEORGE W. BELL RESIDENCE. The 1903 residence George W. Bell at 390 Bedford Road is seen here. He was the owner of Bell Department store in Pleasantville, later changed to George's Men Store.

JOSEPH P. REYNOLDS RESIDENCE. The Joseph P. Reynolds residence in the old village on the north corner of Broadway and Manville is still there today.

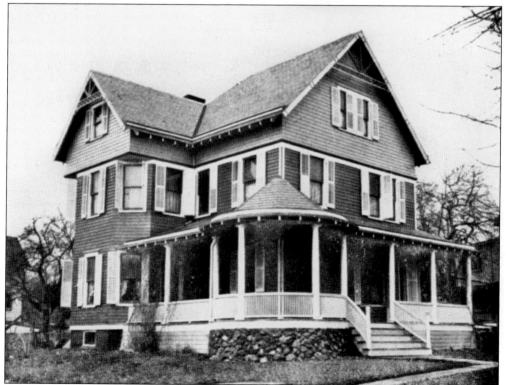

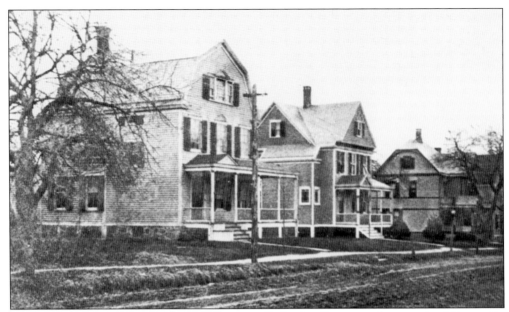

SUNNYSIDE AVENUE. This is the 1903 Pleasantville Realty Company photograph of Sunnyside Avenue. It was formerly the Daniel D. Earle 50-acre farm. Earle had Levi Fletcher See subdivide his farm for the homes on Sunnyside and Martling Avenues.

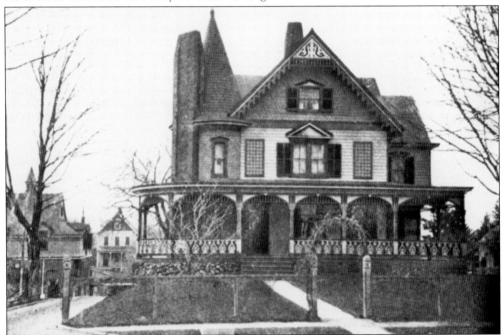

S. WOOD CORNELL RESIDENCE. This is the 1903 Pleasantville Realty Company photograph of the S. Wood Cornell residence. It is now the parking lot next to the Presbyterian Church at 400 Bedford Road. Cornell opened the lumber and coal yard in what is now known as Memorial Plaza before the age of 21. He is long remembered for managing to provide coal to all residents during the national emergency known as the great Coal Strike of 1902. He would later donate property to facilitate the building of Memorial Plaza.

Three

THE LOST PLEASANTVILLE CAVE

The Pleasantville cave—myth or reality? Families who have lived in the village for generations are aware of rumors about a deep extensive cave. The first tenant farmers reportedly told oral histories of Native American tribal ceremonies in a vast cave. They told of folklore that the cave stretched to the Hudson River, outlandishly one Weckquaeskeck elder asserted the cave provided a safe passageway under the Hudson to the Palisades on the other side!

The myth continues that during the Revolutionary War, Gen. George Washington used the cave as a clandestine site for munitions and for caring for the wounded after the Battle of White Plains. The myth continues that the cave was later used to hide runaway slaves as part of the Underground Railroad, until a lost colt wandered into the cave and its owner covered the cave's entrance so he would never lose a prized possession again.

Ultimately, what is left are 100-year-old accounts of the cave's approximate location and descriptions of locals going into the cave by candle and hearing the sounds of carts traveling on Broadway above. There are hand-drawn maps as well as research documenting efforts to find the cave. A critical thread that must not be overlooked is that with each reference to the cave, the element of secrecy exists. Certainly, the location of ancient tribal ceremonies, the storage of valuable war-munitions and wounded, the hiding of freedom seekers from ruthless bounty hunters, and a farmer seeking to eliminate a dangerous hazard to livestock or young children would not be publicized.

Nevertheless, there are skeptics—members of the speleological community who know that Westchester County has few caves, and those known caves are quite small and do not fit the description of the Pleasantville cave. Finally, a key fact must be considered that geologists specifically state that big caverns are known to exist where there are large deposits of limestone, and it is well-known that the former limestone quarry in Thornwood is a short distance from the Bank Street Cemetery in Pleasantville.

CRANDALL PART ONE. John E. Crandall was the Pleasantville Village historian and curator for more than 25 years. During his tenure, he compiled the largest collection of information in existence about the lost Pleasantville cave. This March 6, 1983, letter to Mrs. Runyon is part of his paper trail. The query regarded William Minnerly, who was born in 1856, and boasted to Pleasantville locals that he knew the location and had ventured into the lost cave.

March 6th 1983

Mrs. Runyon,

I have had the pleasure of hearing your name since I began historical research in the area of Mt. Pleasant for over 25 years.

Recently I had the pleasure of receiving a copy of the MINNERLY genealogy compiled by you in 1981 from a member of the Tarrytown North Dutch Church .

Two years ago I compiled a listing of souls from the BANKS CEMETERY, Broadway, Pleasantville which, to my knowledge had not been done before. Would like to list for you some of the MINNERLY families found in the cemetery for your inclusion:

MINNERLY, John S. 3-12-1838/2-6-1893
 Ann E. 7-27-1840/5-10-1915

 Sarah 1858-1875
 Melvin 1860-1878
 George 1871-1877
 Howard 1879-1879
 Melvin F. 1883-1884
 Minnie F. 1884-1891
 Albert J. 1881-1921

MINNERLY, William J.
 Esther W., his wife 1860-1891
 William LeRoy-their son 1891-1915

As you can descern, not many of the offspring lived very long. How tragic it must have been for the respective members of the families.

A bit of folklore which has been handed down from elder community residents and passed on to me....William Minnerly in an interview done sometime in the late 1930's-early 1940's states that he was born about 1856 in Pleasantville and recalled that as a boy ventured into the Pleasantville Cave located in the Old Village. William Minnerly served as custodian of the

CRANDALL PART TWO. Crandall had discovered a 1906 *Pleasantville Journal* article written by Elliot See, who was about 65 years old at the time, reporting that his father, Abel See, had told him he went into the lost cave by candle all the way to Broadway, where he could hear wagons overhead. Crandall also found an article from July 1914 in the *Magazine of American History*, Vol. XLIII, No. 7, titled "The Old Kettle Hole," with information consistent with that of Abel See.

-2-

cemetery (the author does not articulate whether it was the BANKS CEMETERY or the old METHODIST CEMETERY, located on the West side of Broadway, diagonally across from each other). It seems that William Minnerly would lose crowbar's when "excavating" (digging graves I assume).

Another folklore given is the one about the "haunted house" of the Minnerly premise, located just north and adjacent to the old Methodist Cemetery plot, later owned by the Reinisch family and recently occupied by Edward Tuttle family. Both families substantiate the oddities of the house (perpetuated hysteria?).

It seems that the MINNERLY family then living in the little white house had recently lost a daughter at a very young age. A while after her death the family began to notice disturbances in the house;- cold air drafts, the front door opening (always stuck upon normal conditions); footsteps on the stairs leading upstairs. The recent occupants of the house have complained about the telephone being taken off the hook and related. Manifestations such as these are not within the realm of historic validation but do make for interesting social history!

Would you be kind enough to send along a copy of the MINNERLY compiliation and supplement. Please let me know the cost and will send along some money for your efforts. "Bunny" _____ (the last name escapes me) lent her copy to me.

Hope to hear from you.

Best wishes,

J. E. Crandall

John E. Crandall
Village Historian
P'ville
Curator - MPHS

GIBBONS. It was not until John Crandall met Howard DeVoe—a Pleasantville resident who wrote a seventh-grade essay on the cave in January 1946 and who had discovered the maps of Dr. Brainard Frederick Gibbons—did the motherlode of data appear. This February 12, 1952, letter from Gibbons to young DeVoe connected two of the foremost cave experts from Pleasantville.

First Universalist Church

BRAINARD F. GIBBONS, Pastor
904 GRANT STREET
HOME TELEPHONE 3532 CYRUS YAWKEY HALL 3897

Wausau, Wisconsin
February 12, 1952

Mr. Howard DeVoe
104-B Federal Hall
Oberlin College
Oberlin, Ohio

Dear Howard:

 As promised back in September, I have gone through my diaries and sifted out material concerning Pleasantville's lost cave and made a typewritten copy of the material. A carbon is enclosed. This information, of course, is purely for your personal use in connection with your research on the cave, etc.

 By now, you have entered your second semester of college and I trust that you passed the first one successfully and are anticipating the remainder of your year. It will be gratifying to have your report as to how this running information I have fits into the pattern of other information you may have gathered, etc.

 Cordial regards.

 Sincerely,

 Brainard F. Gibbons

BFG/eak
enc.

Top Universalist

Those hard-working freethinkers, the Universalists, learned last week that they were soon to get a new General Superintendent. After 15 years in the office, the nearest a Universalist can come to being a bishop, Dr. Robert Cummins, 55, announced that he was retiring because "it

Toburen Studio
SUPERINTENDENT GIBBONS
Ready to join the union.

has always been my custom to leave a church while I am still cherished." His successor: peppy, Brooklyn-born Dr. Brainard Frederick Gibbons.

Universalist Gibbons, 51, began as a Manhattan lawyer, served in the firm of the late Chief Justice Charles Evans Hughes, and eventually set up his own practice. In 1936 he quit "to do something for society rather than just make money out of its difficulties," and went to St. Lawrence University's theological school. Dr. Gibbons' parish since 1942 has been a small one, the First Universalist Church at Wausau (pop. 30,414), Wis., but he has attracted plenty of attention with the vigorous anti-orthodoxy of his speeches around the country.

Dr. Gibbons will preside over a critical new chapter of Universalist history. By this summer, his 64,000-member church may be ready for a federal union, long discussed with U.S. Unitarians (membership: 80,000).

TIME, MAY 11, 1953

UNIVERSALIST. Brainard Frederick Gibbons grew up in Pleasantville during the late 1920s. As a young man, he conducted many cave excavations. Moreover, he was a meticulous note taker. Gibbons would reach great heights upon leaving the village, as this *Time Magazine* article attests. He too shared Elliot See's 1906 view that, "it would be of interest to the people of the community if the cave could be reopened."

Vol. 33, No. 3 - July, August, September, 1957

THE WESTCHESTER HISTORIAN

PLEASANTVILLE'S LOST CAVERN
1882 - 1957
By HOWARD DEVOE

A TRADITION has long been extant among residents of Pleasantville that there exists in that town an extensive natural cavern, its entrance for decades sealed and its exact location forgotten. This tradition is substantiated by a good deal of information which has been collected by several interested persons over the past twenty-five years. It appears that the cave was known in the last century, and that it became closed to entrance of man about eighty years ago. Despite numerous available hints concerning its location, and some energetic attempts to recover the entrance, the cave to this day remains lost.

The available information places the entrance somewhere along the western slope of a small wooded ravine which runs from north to south at the rear of the Banks Cemetery in Pleasantville. Four properties adjoin this ravine. From the entrance, the course of the cave is apparently westward beneath the cemetery, toward Broadway (route 141) which is six hundred feet from the ravine. All traces of the entrance have disappeared under the shallow layer of soil and humus which covers the white limestone bed rock in the ravine. But there is good evidence here of the conditions which are necessary for the formation of a natural limestone cavern. Two interesting six foot deep potholes demonstrate the existence of vigorous ground water activity at some ancient epoch. Furthermore, evidence of unusual undergound permeability is furnished by the behavior of a small stream which passes through the bottom of the ravine. This stream, which flows only following heavy rain, usually completely disappears into the ground at some point along the ravine.

To the writer's knowledge, the only account of the cave by one who was acquainted with it while it was open was written by Elliott H. See of Pleasantville. A copy of his article for a local newspaper was preserved by his daughter, the late Mrs. Chester Purdy. This clipping is undated; Mrs. Purdy believed that it was written about 1906, when E. See was sixty-six years of age. The type face of the clipping suggests that it was published in the PLEASANTVILLE JOURNAL. It is reproduced in full here:

So Called Old Poker Hole.

Probably very few living in this vicinity at the present time know of the existence of a cave within the corporate limits of Pleasantville. In a ravine on the west side of Mr. George Robbin's farm and a few rods southwest of Mr. Stephen R. Smith's residence is or was, an entrance to a cave. About forty-eight years ago Mr. Charlton Millrose and others dug away the earth at the entrance so that a man could easily enter in an upright position. Abram See with another started with a lighted candle and followed the cave through what is now the Banks Cemetery 'till they reached a point under the roadway near the present horseshed. They said at the time they could hear a wagon passing overhead. They then retraced their steps, probably fearing to go further. About this time a young colt belonging to Mr. Benj. Hays wandered in there and never again appeared at the entrance. People for a long time after came

THE WESTCHESTER HISTORIAN

miles to see the cave. As a small stream was running close by, the entrance soon began to fill up, and for many years it has been entirely hidden, but the writer and a few others can point out the exact spot. Mr. Elijah Montross remembers entering the opening for a short distance at that time. It would be of interest to the people of the community if the cave could be reopened.

E. H. See.

It can be seen that this article sheds little light on the exact location of the entrance. The above-mentioned Abram See was Elliott See's father. If Abram See actually reached a point in the cave under Broadway, which is about six hundred feet from the entrance, then it must be a good sized cave. Though this may seem short, it is a common experience for distances to appear enormously exaggerated in underground gloom. There are no natural caverns of this length known in Westchester, and none this long in all of New England.

Randall Comfort makes brief mention of this cave in an article entitled "The Old Kettle Hole (WESTCHESTER COUNTY MAGAZINE, July 1914) He resided from 1914 to 1926 on land adjoining the ravine. The title is a misnomer, as "Kettle Hole" is actually the name given to a small cave near Valhalla.

At different periods since 1932, the following three persons interviewed residents of Pleasantville and vicinity who had been in the cave as youngsters or who had indirect knowledge of it: Brainard Gibbons, a local attorney (between 1932 and 1934); Allison Albee, W.C.H.S. president (beginning about 1937); and the writer (beginning in 1945). Among the information thus collected were these interesting but questionable assertions: that the cave was utilized by Washington's troops for storage of supplies in 1776; that it served as a hiding place for escaped slaves on the underground railroad route which passed through Pleasantville; that it was upon occasion a "residence" of the celebrated Leath erman of the last century.

A tradition which appears to rest upon a more secure foundation is that the entrance was intentionally filled in by a local farmer whose prize colt had in some way been killed in the cave. Elliott See's newspaper article mentions the colt incident in connection with Benjamin Hays, who owned property to the north. But Elijah Montross claimed that the person who lost the colt and subsequently sealed off the entrance was Stephen Palmer, who appears to have owned the land at that time. The tradition contradicts the implication of E. See's article that the entrance was accidentally closed by the stream which runs through the ravine. Furthermore, John I. Thorne, Millard Taylor and Wright Palmer (all of whom had seen the cave when young) remembered that the entrance was part way up the western slope of the ravine. If one accepts this, then it is difficult to believe that the stream at the bottom could have been responsible for its closing.

Where is the entrance located? Unfortunately, of those interviewed who had first hand experience of the cave all but one had seen it as youngsters more than fifty years before, and were understandably hazy about the exact location. The exception is Elijah Montross (born about 1835) who showed the approximate location to Wilson R. Yard around 1906.

DeVoe One. Howard DeVoe published this scholarly piece titled, "Pleasantville's Lost Cavern 1882–1957," in the *Westchester Historian*, Vol. 33, No. 3, July-August-September, 1957.

DeVoe Two. DeVoe collected Gibbons's notes and maps and expanded his research. He contacted dozens of families and conducted exhausting excavations.

34

DeVoe Three. DeVoe shared his Gibbons research with John Crandall. He also volunteered his own extensive research. Crandall incorporated his individual work and collectively compiled a book with 100 pages of notes and maps. It is clearly the Rosetta Stone of the Pleasantville cave.

Scythe Cemetery. This July 17, 1958, photograph is of the elderly William Marquette sharpening his scythe among the gravestones in the old Methodist Church graveyard on Broadway. He was the caretaker of the cemetery. Along with the Bank Street cemetery across the street, the two cemeteries included the graves of some of the oldest families in Pleasantville. For years, locals alleged that William Minnerly had passed Marquette the secret location of the cave.

Montross claimed to have gone as far as Broadway through the cave. William Minnerly (born about 1856) also claimed to have followed the cave through to the road as a boy. Minnerly liked to relate that as caretaker of the Banks Cemetery, he occasionally lost implements into fissures in the underlying rock while digging graves — perhaps into the cave itself. He called it "Poker Hole," as does E. See's account.

Millard Taylor, William Minnerly and Robert Kinney remembered the entrance to be near a large hickory tree. Mr. Kinney believed it consisted of a vertical shaft in the limestone, from the bottom of which one gained access to the main cave through a low horizontal tunnel.

Wright Palmer and William Minnerly went over the ground with Brainard Gibbons in 1932, and Mr. Palmer also pointed out the approximate location to Mrs. Stephen Holden at about the same time. But they were uncertain of the accuracy of their memories. In fact, Minnerly suggested two places seventy-five feet apart. The recollections of others who remembered the cave were equally ambiguous.

The year of the cave's closing can be only approximately established. Wright Palmer played in the cave about 1870 as a boy, and Millard Taylor saw the cave about 1873. Frank Zarr, who was born about 1873, stated that the entrance was closed "*before he was old enough to toddle.*" Watson Yerks said that he saw the entrance about 1878, but possibly he was referring to the closed entrance. E. See's article indicates that the opening had disappeared well before the article was written, probably the first decade of this century.

In addition to conducting historical research, Brainard Gibbons, Allison Albee and the writer have excavated with hand tools to uncover the bed rock in several parts of the ravine. These efforts have not been the only ones. Among other ambitious attempts to recover the entrance were those of Stanley Grierson of Katonah in 1946 and 1949; and of members of the New York chapter of the National Speleological Society in 1952 and 1953. The speleology group made three field trips, resorted to a pneumatic drill which made no impression in the hard limestone, and conceded that its business was exploring caverns rather than trying to make them!

An elegant but debatable way of locating the position of an underground space is the mysterious technique of "water dowsing." Two amateur dowsers have explored the area. In 1950 Frederick van Davelaar, a New York physicist, used a heavy wire loop held in his hands; two years later, Russell Gurnee of the speleology group tried a less sophisticated wild cherry stick. To the writer's astonishment, both men picked out the identically same course with the greatest of ease. According to them, from the ravine the cave proceeds directly under the southeast corner of the Banks Cemetery, and thence beneath the cemetery toward Broadway. They claim that several yards west of the ravine the cave has a branch which leads southward to the property line of the New York-Catskill aqueduct, four hundred feet distant. Verification awaits recovery of the entrance, which was not unambiguously located by the dowsing method.

To repeat Mr. See's words, "*It would be of interest to the people of the community if the cave could be reopened.*"

— [74] —

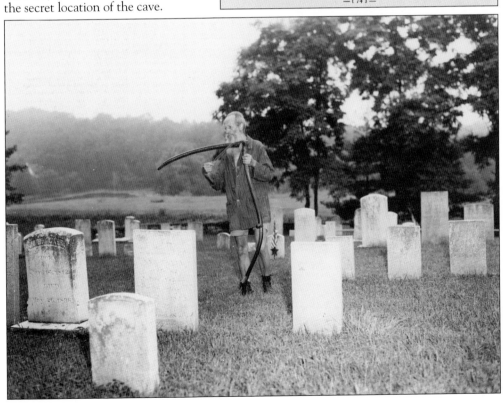

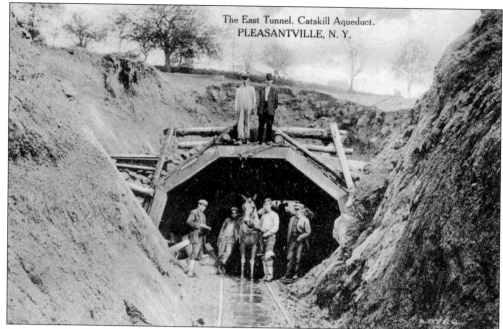

TUNNEL. The Catskill Aqueduct was constructed adjacent to where the cave reportedly lies. However, while there were several rumors of vast caverns, the crews never filed an account for fear of not maintaining the strict targets of the tunnel contract, according to oral historians.

PHEBE. Phebe Holden Washburn grew up on Hoanjovo Lane. She has heard all of the folk stories about the lost Pleasantville cave her entire life. The family property backs up to the Bank Street cemetery.

HOLDEN FIRE. This January 11, 1941, blaze destroyed the Holden home on Hoanjovo Lane.

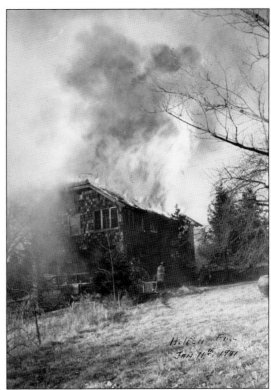

CARRIAGE. This 1905 photograph of the Hall family in their horse-and-buggy is typical of what local land transportation represented.

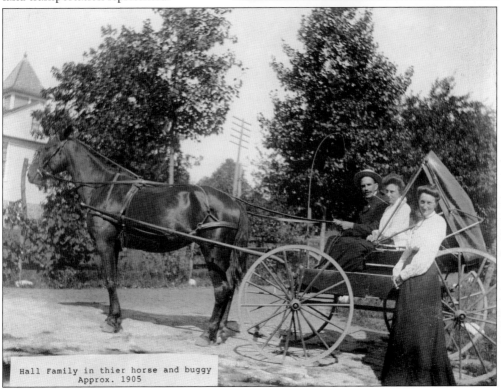

Hall Family in thier horse and buggy
Approx. 1905

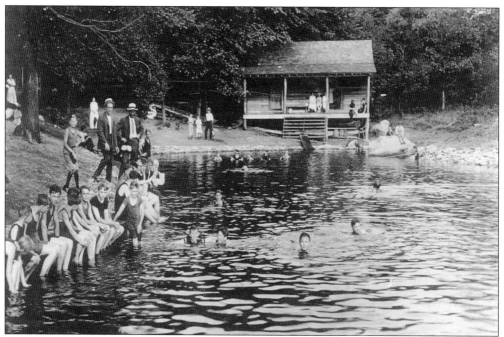

POOL. Pictured is the original Pleasantville pool near Lake Street and Broadway, located in between the Bank Street cemetery and the Thornwood quarry.

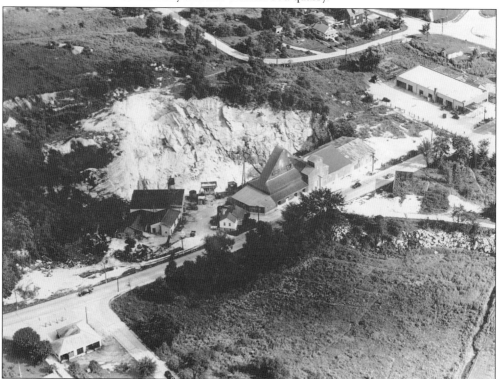

QUARRY. The Thornwood quarry was a vibrant business for decades. This aerial photograph offers a wide view of the area's development.

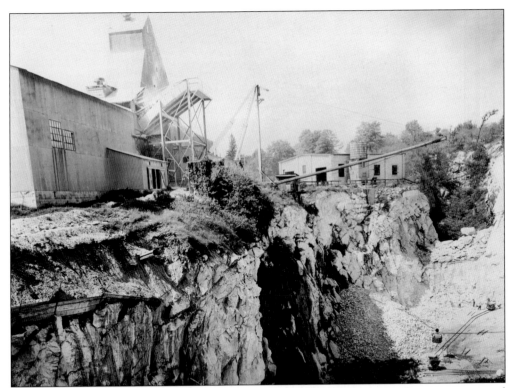

QUARRY. This is an up-close look at the Thornwood quarry. Marble from the quarry was used in the construction of St. Patrick's Cathedral in New York City and the US Custom House in New Orleans.

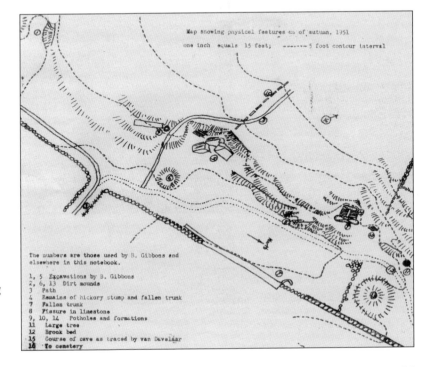

Map showing physical features as of autumn, 1951

one inch equals 15 feet; - - - - - 5 foot contour interval

The numbers are those used by B. Gibbons and elsewhere in this notebook.

1, 5 Excavations by B. Gibbons
2, 6, 13 Dirt mounds
3 Path
4 Remains of hickory stump and fallen trunk
7 Fallen trunk
8 Fissure in limestone
9, 10, 14 Potholes and formations
11 Large tree
12 Brook bed
15 Course of cave as traced by van Davelaar
16 To cemetery

MAP. There were several maps made while searching for the cave. This map is from the fall of 1951.

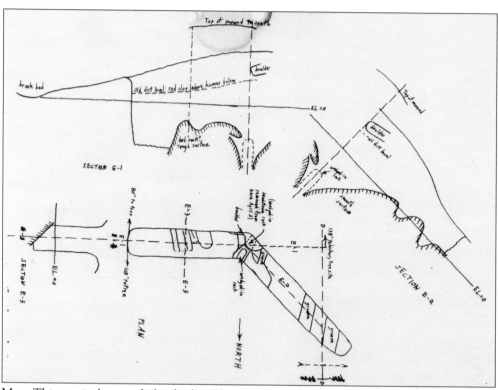

MAP. This particular search for the lost Pleasantville cave is marked in a map of sections E-1, E-2, and E-3.

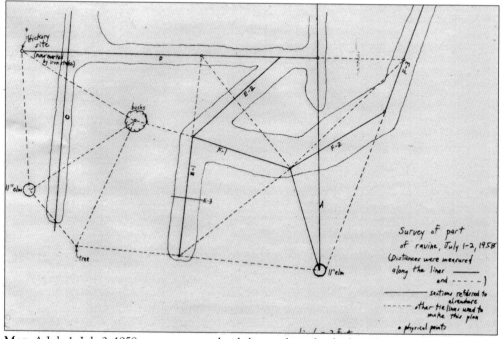

MAP. A July 1–July 2, 1958, survey was made while searching for the lost Pleasantville cave. There are more than one dozen maps of cave searches in the John Crandall archives.

Four

CLARK'S CORNERS
TO PLEASANTVILLE

Henry Clark settled in Pleasantville in 1795. The Clark families were early residents of Bedford. Clark opened a tavern at the corner of Broadway and Bedford Road. It was the start of a small hamlet commonly referred to as "Clark's Corners." Originally, the region was called "Bever Meddow" (Beaver Meadow) according to Samuel and James Dean's 1743 archives of local meetings. The tavern soon became a horseback mail drop for nearby Hudson River trading posts. In 1828, Henry Romer became the proprietor of the general store at Clark's Corners and assumed responsibility for the mail. He immediately petitioned the US Post Office to nominate an official designation for Clark's Corners. He initially selected Clarksville and Mechanicville. However, it was discovered that the names already existed. Consequently, Romer uniquely coined the village Pleasantville and the designation became official on February 29, 1828. Around 15 years later, the Hays Hotel, a three-story lodging and stagecoach stop, was erected on the northeast side of Clark's Corners.

In October 1846, the New York Harlem Railroad extended its line from White Plains to Pleasantville, nearly a mile west of Clark's Corners. Passenger traffic, commercial deliveries, and mail gravitated to the new Pleasantville railroad station ending the central importance of the store and hotel. To this end, the economic shift in activity ushered in the era of calling Clark's Corners "The Old Village." Agriculture was the primary means of income for many residents. However, archives indicate the face of local industry included four shoe factories, two pickle factories, a shirt factory, a chocolate factory, a limes works, and a lumber mill. The shoe industry dwarfed all others, and in 1858 locals joked, "Everybody is a shoemaker but the minister . . . and he makes his own." The official incorporation of the Village of Pleasantville took place in 1897. By the turn of the new century, Pleasantville was still primarily a farming community with a population of 1,500. However, it would soon grow to be the first Mount Pleasant community with a high school, library, bank, paved roads, sidewalks, and kerosene street lamps.

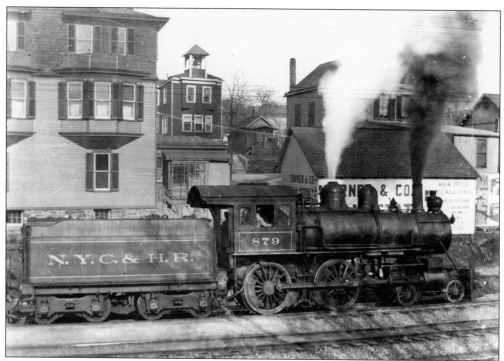

THE TRAIN. The New York Central and Harlem Railroad arrived in Pleasantville in October 1846. It changed the dynamics of the village. Clark's Corners would no longer be the center of the community, as it would slowly gravitate to the train station on Wheeler Avenue. This photograph is of Wheeler Avenue and the Thorn Building, better known as Sunset Hall, in the background. On the left is the side of Conlon's Hotel. (Courtesy of Pleasantville Village Archives.)

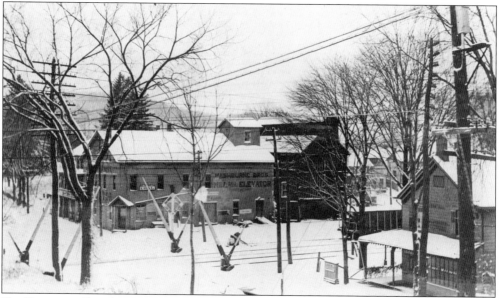

THE RAILROAD. Seen here is an 1890 winter view of the railroad crossing. The George Washburne Building on the right burned in November 1896 and became the site of Lane, Eaton, and Smith. (Courtesy of Pleasantville Village Archives.)

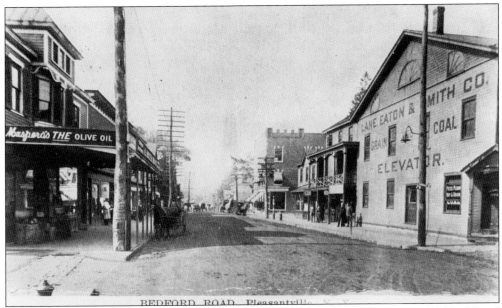

LANE, EATON, AND SMITH. Lane, Eaton, and Smith grain and coal elevator on Bedford Road serviced residents from the entire Mount Pleasant community. (Courtesy of Pleasantville Village Archives.)

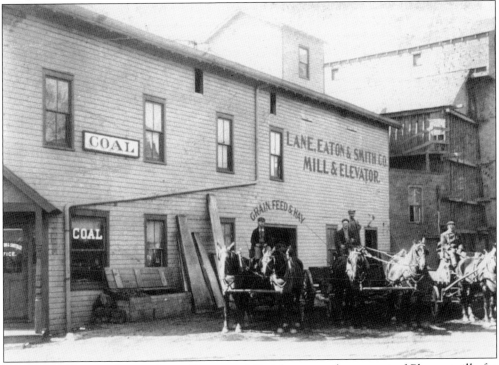

LANE, EATON, AND SMITH. Lane, Eaton, and Smith was a vibrant part of Pleasantville for decades. The owners were dedicated members of the community and proud parents. They were also active in the economic growth of the village and regular supporters of the Memorial Day holiday. (Courtesy of Pleasantville Village Archives.)

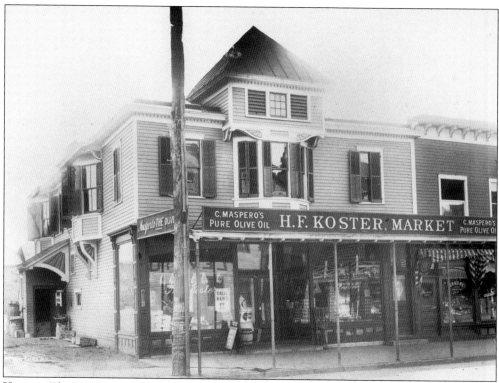

KOSTER. The H.F. Koster Market was across the street from Lane, Easton, and Smith on Bedford Road. Henry Koster bought the building from George Washburne around 1900. (Courtesy of Pleasantville Village Archives.)

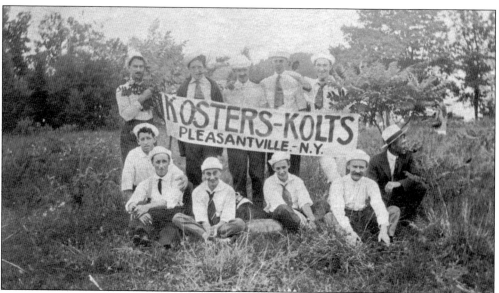

KOSTERS KOLTS. The H.F. Koster Market Kolts participated in holiday events within Pleasantville for years. (Courtesy of Pleasantville Village Archives.)

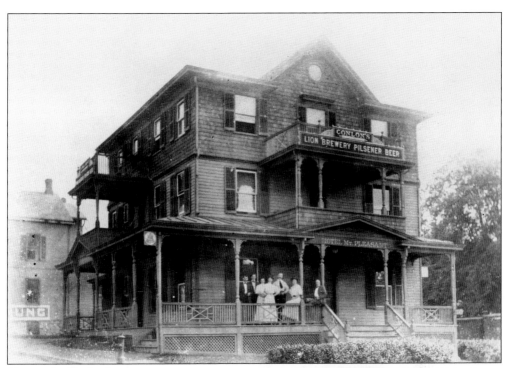

CONLON'S. Conlon's on Wheeler Avenue was formally known as the Mount Pleasant Hotel, but it was also well-known for its bar that served cold Lion Brewery Pilsner Beer. The staff of Conlon's proudly posed for this photograph on the front porch. New Yorkers would frequently spend weekends in Pleasantville for the fresh country air. (Courtesy of Pleasantville Village Archives.)

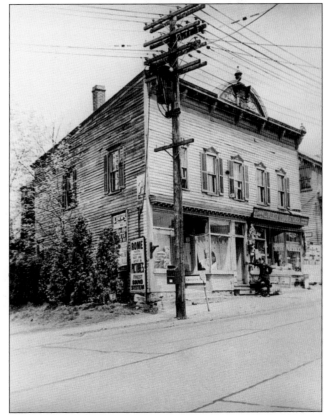

THE LIBERTY FOOD STORE. The grocery store on 479 Bedford Road is now the site of the ever-popular Foley's Club Lounge. (Courtesy of Pleasantville Village Archives.)

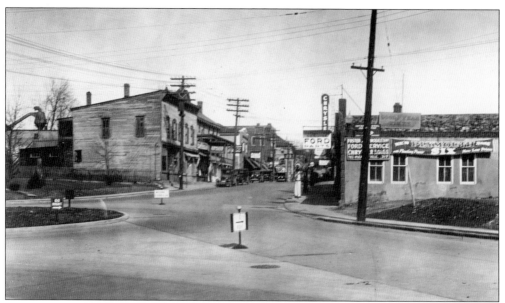

FOLEY'S FROM A DISTANCE. The Liberty Food Store, now Foley's, on Bedford Road is viewed from a distance. Pleasantville was a growing community as evidenced by the small businesses along Bedford Road. (Courtesy of Pleasantville Village Archives.)

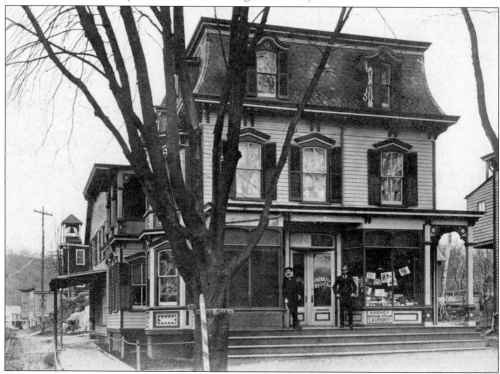

CORNER OF BEDFORD ROAD AND WHEELER AVENUE. The corner of Bedford Road and Wheeler Avenue is seen here with two men standing in front of the *Pleasantville Journal* office. Note the street sign with Pleasantville in front of the tree with the arrow pointing to the old village. (Courtesy of Pleasantville Village Archives.)

BEDFORD ROAD. The Bogen building would become Cadman's Pharmacy. However, in this 1904 photograph, the original Mount Pleasant Bank and Trust Company is open for business. To the right of the bank is Holy Innocents Church. On the other side of the bank is Gibson's five-and-dime, Reynolds Bakery, and a barbershop. (Courtesy of Pleasantville Village Archives.)

BEDFORD ROAD OVERLOOKING GRANDVIEW AVENUE. Pictured is a broad view of Bedford Road overlooking a barren landscape. The land in the distance is what would eventually become Eastview and Grandview Avenues. (Courtesy of Pleasantville Village Archives.)

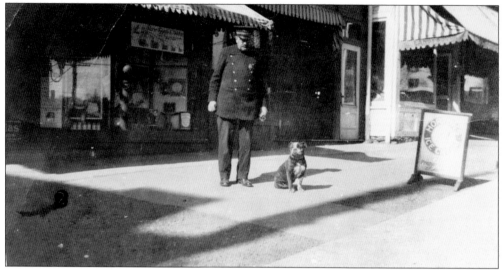

Capt. George Poth. Capt. George Poth was Pleasantville's first police officer. Here, he is with his trusted dog, Colonel. Poth was well-respected for his role in maintaining the quarantine of the Rebecca Road cold-water flats in 1902 and also for single-handedly capturing horse thieves that raided the Manville family's prized stables. (Courtesy of Jacky Fowler.)

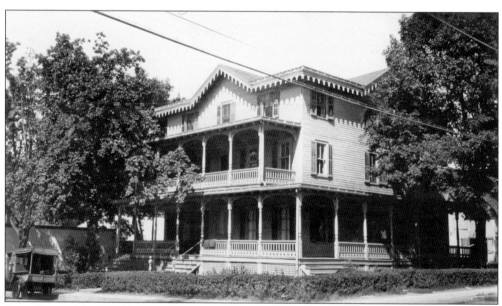

Huff Hotel. The Huff Hotel on the corner of Manville and Washington Avenue (the site of Dunkin' Donuts) was built in 1888 and was torn down in 1951. The wraparound porch on the first floor and street-side porch on the second floor were very popular with guests. The Huff Hotel reportedly had the first telephone in Pleasantville. (Courtesy of Pleasantville Village Archives.)

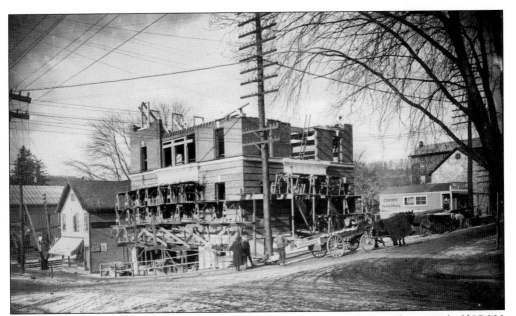

MOUNT PLEASANT BANK. The Mount Pleasant Bank was founded in 1904 with a capital of $25,000 and a surplus of $5,000. It was the first bank in Mount Pleasant. The bank originally opened in the Bogen Building next to Cadman's until this structure was completed in 1910. S. Wood Cornell was the first president. At the end of the first year, deposits exceeded $160,000, and 10 years later, deposits were $4.5 million. (Courtesy of Pleasantville Village Archives.)

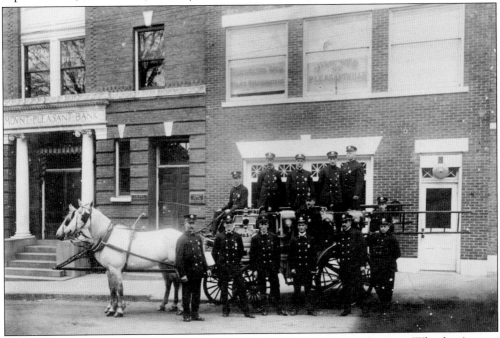

PIONEER ENGINE CO. This 1910 photograph shows the Pioneer Engine Co. 1 on Wheeler Avenue with the newly constructed Mount Pleasant Bank on the left and police headquarters with the village of Pleasantville offices behind them. Pioneer Engine Co. 1 was founded on December 10, 1894. (Courtesy of Pleasantville Village Archives.)

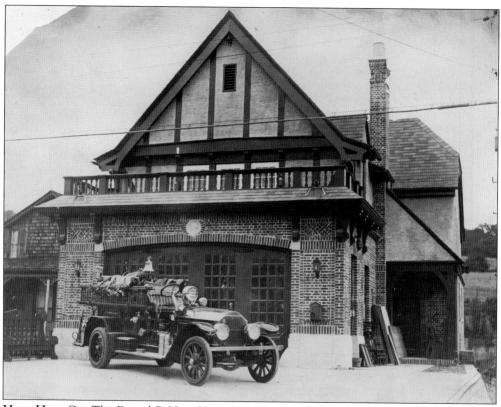

HAYS HOSE CO. The Daniel P. Hays Hose Company was founded on November 2, 1901. This photograph displays new equipment in front of the new firehouse. Notice the open fields behind the firehouse. (Courtesy of Pleasantville Village Archives.)

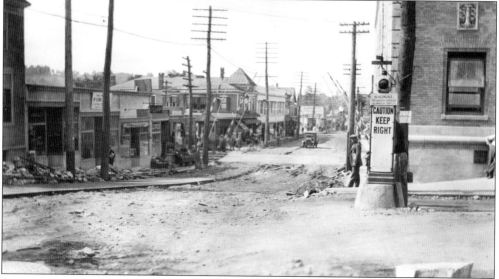

BEDFORD ROAD CONSTRUCTION. The 1928 construction of Bedford Road, complete with pedestrian sidewalks, was a major enterprise. The new Mount Pleasant Bank is on the right and Koster's Market and Bell's Department Store are on the left. (Courtesy of Pleasantville Village Archives.)

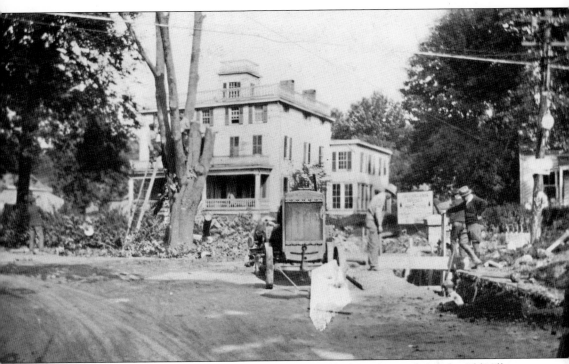

OLD VILLAGE CONSTRUCTION. The 1928 construction on Bedford Road extended to the Old Village. The new road was the pride of the community. (Courtesy of Pleasantville Village Archives.)

BEDFORD CONSTRUCTION. The expansion and construction of Bedford took place in the early 1930s. This section is north of the Methodist Church and just short of the Manville estate (Foxwood). (Courtesy of Pleasantville Village Archives.)

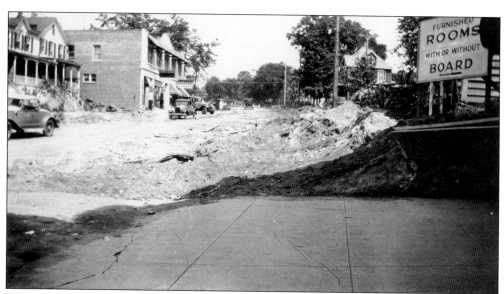

REBECCA AVENUE. Construction of Rebecca Avenue, named after Rebecca Pierce, is seen here during the 1928 construction. Note the cold-water flats on the left where the 1902 smallpox epidemic and quarantine took place. (Courtesy of Pleasantville Village Archives.)

Five

HOUSES OF WORSHIP

Methodism first came to Pleasantville during post–Revolutionary War days. It all started in the 1780s, when a lone circuit rider traveling on horseback established a Methodist society at the home of Jesse Baker on Bear Ridge Road. Those early Methodists were a serious group, abstaining from alcohol and gambling and extolling the virtues of scripture, experience, reason, and tradition. St. John's Episcopal Church has been a part of the Pleasantville community since 1853, when it was established as a mission church of Grace Church in White Plains. The Rev. Robert W. Harris was rector of Grace Church and priest-in-charge at St. Johns in Pleasantville during services in the Old Village Schoolhouse. The present church was built in 1912 under the rectorate of the Rev. Dr. Stephen Holmes. The beautiful stone facade, classic architecture, and stained-glass windows in the sanctuary are features that make the church a landmark in the village.

Holy Innocents Catholic Church started as a mission church of St. Francis of Assisi in Mount Kisco. Mass was first celebrated in 1875 at Sunset Hall on Wheeler Avenue. The present property on Bedford Road was donated by Samuel Schapter on the condition that it be named Church of the Holy Innocents. Our Lady of Pompeii, a mission church built mostly by the Sicilian congregation in 1918, was incorporated into the parish in 1929. The Presbyterian Church of Pleasantville was organized in 1880. Services were held at Sunset Hall. The cornerstone of the current church on Bedford Road was set in 1881. The church has a strong Sunday school and youth program. The Swedish Emanuel Lutheran Church was organized in 1893. The church on Manville Road was completed in 1955. The next year, Rev. John Pearson became pastor and became a dynamic force in Pleasantville. He boosted the congregation from 180 to more than 900 members. The Pleasantville Community Synagogue was founded on Bedford Road in 1997. Mark Sameth led Shabbat services and became the first rabbi upon his ordination from seminary in 1998. *The New York Times* hailed the "lusty singing and dancing" of Rabbi Sameth's joyous musical services.

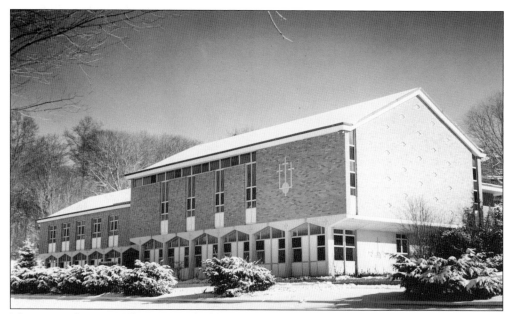

METHODIST CHURCH. The First Methodist Church was built in 1820 at the site of what is now the old Methodist cemetery located in the Old Village. The Central Methodist Church was formed in 1888 on Bedford Road to be closer to the train station. The two churches merged in 1948. The name changed to the United Methodist Church in 1968. Funds for the current church at 70 Bedford Road were raised in 1961and the architect was Kenneth Gibbons.

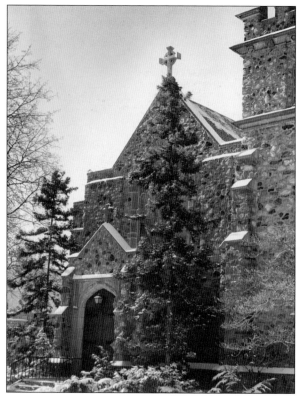

ST. JOHN'S. St. John's Episcopal Church was founded in 1853 with services at 219 Bedford Road. The current location at 8 Sunnyside Avenue was completed in 1912. The beautiful stone facade, classic architecture, and stained-glass windows in the sanctuary make the church a Pleasantville landmark. St. John's Rectory next door to the church on Bedford Road dates back to 1785 and is the oldest house in Pleasantville.

HOLY INNOCENTS. The first Catholic masses were celebrated monthly at Sunset Hall on Wheeler Avenue in 1875. The first church at 431 Bedford Road was built in 1876. This photograph is of the second Holy Innocents Church, in use from 1913 to 1985. The current church was built in 1987 with the inscription, "How wonderful it is . . . How pleasant . . . For God's people to live together in harmony." The highly regarded Dominican father Terence Quinn was pastor of the new construction.

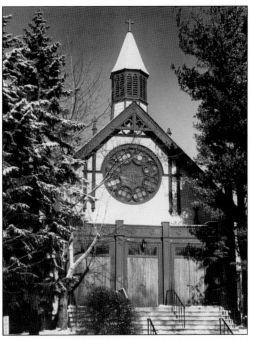

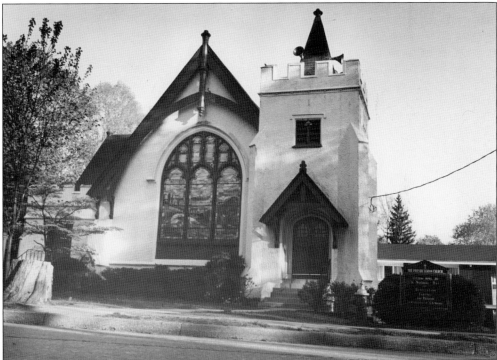

THE PRESBYTERIAN CHURCH. The Presbyterian Church at 400 Bedford Road was organized by 13 men and women on January 18, 1880. The first Presbyterian services were held at Sunset Hall, over John Thorn's livery stable on Wheeler Avenue. The cornerstone of the current church was laid on November 2, 1880. The church has been rebuilt and enlarged three times. The giant stained-glass window in front of the church is one of Pleasantville's treasures.

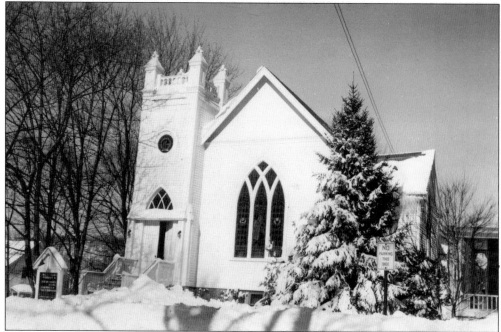

THE ORIGINAL PRESBYTERIAN CHURCH. The original Presbyterian Church at 400 Bedford Road was replaced with a larger house of worship as the congregation grew.

LUTHERAN CHURCH. The Swedish Emanuel Evangelical Lutheran Church of the old Augustana Synod was first organized on November 11, 1893, by a small devoted group of Scandinavians, who had come to Pleasantville primarily from Sweden. They originally met in a meeting hall over Washburn's Grocery Store on Bedford Road next to the train station. The church held 32 services and baptized three infants during the first year. The first congregational meeting was held on December 26, 1894.

PASTOR PEARSON. The beloved John R. Pearson was pastor of the Emanuel Lutheran Church for 25 years. During the quarter-century in Pleasantville, he built an enormous legacy of kindness. He retired in January 1981 for health reasons. Mayor John Farrington called the minister "a dynamic force." Pearson was honored by the Pleasantville Lions, Rotary Club, his church, and villagers. In the 1960s, he marched for the civil rights movement with Rev. Martin Luther King Jr.

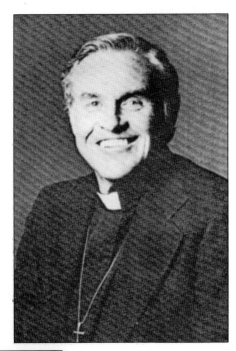

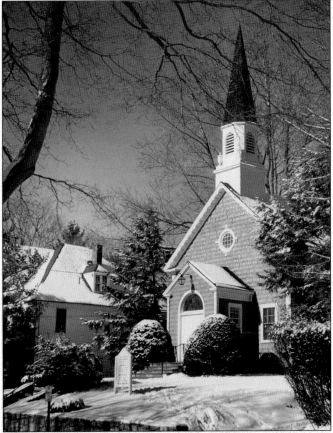

SYNAGOGUE. The Pleasantville Community Synagogue at 219 Bedford Road was founded in the winter of 1997. It prides itself as an inclusive house of worship for all seeking a progressive, spiritually based "Joyful Judaism." The building was the original church of St. John's in 1855 and was then purchased by the Christian Science Church in 1920. *The New York Times* hailed the "lusty singing and dancing" of Rabbi Mark Sameth's uplifting musical services.

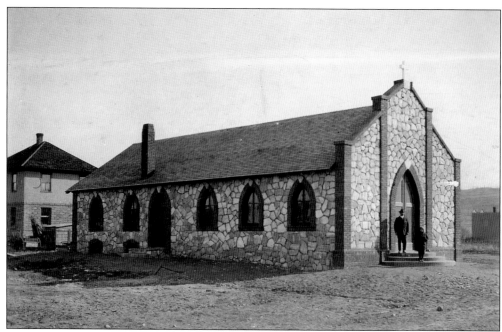

OUR LADY OF POMPEII CHURCH, 1918. Our Lady of Pompeii Church is a mission of Holy Innocents Church. Built in 1918, it is the only church in Pleasantville built stone by stone by parishioners. (Courtesy of Rubino Family Archives.)

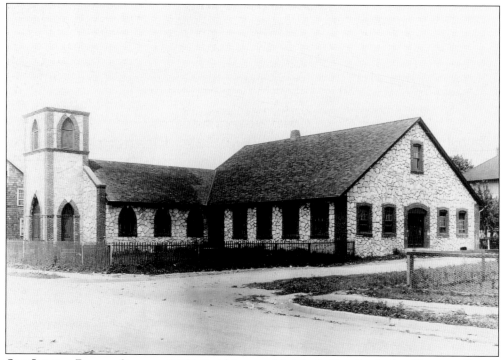

OUR LADY OF POMPEII CHURCH, 1925. Parishioners added the hall to Our Lady of Pompeii Church in 1925. It was used frequently by residents in the Flats for large family gatherings. (Courtesy of Rubino Family Archives.)

FR. ALEXANDER MERCIER. Parishioners of Our Lady of Pompeii built the church under the spiritual guidance of the beloved Fr. Alexander Mercier, O.P., who spoke five languages and whose older brother Louis was the official poet of France. Ordained in France on December 25, 1876, Father Mercier was originally a professor of philosophy and theology for eight years before persecution drove his Dominican Order out of the country. (Courtesy of Rubino Family Archives.)

PROHIBITION. The Internal Revenue Service regulated alcohol during prohibition. This July 28, 1926, application to procure wine for sacramental purposes was submitted by Fr. Alexander Mercier, O.P., on behalf of Our Lady of Pompeii. (Courtesy of Rubino Family Archives.)

TREASURY DEPARTMENT
INTERNAL REVENUE SERVICE
Form 1412—Revised Oct., 1925

APPLICATION TO PROCURE WINE FOR SACRAMENTAL PURPOSES AND LIKE RELIGIOUS RITES

Quantity of wine procured since January 1, 192 **6** **None** gallons.

Quantity applied for herein_____ "

TOTAL_____ "

Quantity on hand date of application_____ "

_____ **July 13th** ____, 192 **6**

Rev. Alexander Mercier , **Rector**
(Name in full.) (Official designation.)

of **Our Lady of Pompeii** , located at _____
(Name of church or congregation.) (Street address.)

Pleasantville Park, Westchester Co. **N. Y.**, hereby makes application to procure
(City.) (State.)

from _____ , _____
(Name of dealer.) (Street address.)

_____ , _____, to be delivered to the above address,
(City.) (State.)

_____ gallons of **Domestic** wine to be used solely for sacramental purposes
(Kind.)

or like religious rites, as provided by the National Prohibition Act; and hereby certifies that the quantity applied for herein is necessary for the purposes stated, and that he is duly authorized to make this application on behalf of the aforesaid church or congregation.

Sworn to and subscribed before me this _____
(Signature of applicant.)

_____ day of _____ 192

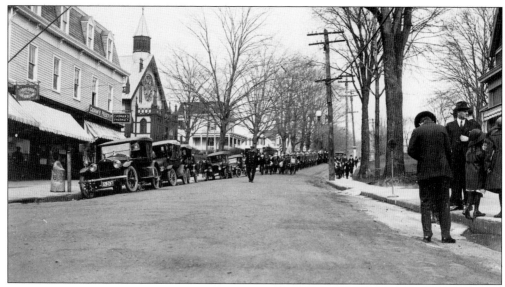

FUNERAL. A funeral for a Pleasantville dignitary around 1930 is seen here. Business owners would typically close shop to attend the procession and services for a village leader. This photograph is of Bedford Road with Holy Innocents Church on the left. (Courtesy of Pleasantville Village Archives.)

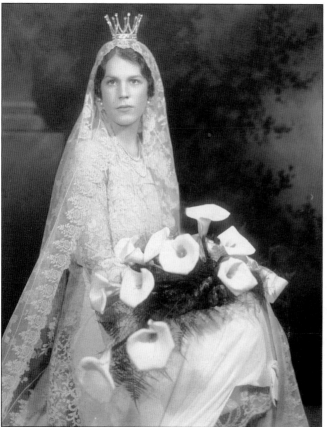

INTERNATIONAL WEDDING. The wedding of Hiram Edward Manville's daughter, Estelle Romaine, to Swedish Count of Wisborg Folke Bernadotte was held at St. John's Episcopal Church on December 1, 1928, and was arguably the most important international social event in the history of Pleasantville. More than 1,000 guests, many in colorful uniforms of Swedish nobility, attended the ceremony. The day after the wedding, the Count and Countess visited President Coolidge and his wife, Grace, at the White House. (Courtesy of Carsten Johnson.)

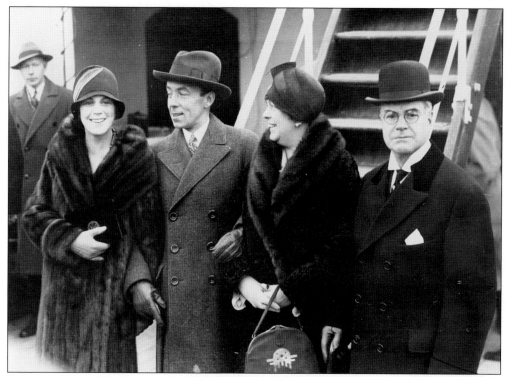

COUNT AND THE MANVILLES. This November 26, 1928, international newsreel photograph is of Estelle Romaine Manville, her fiancé, Count Folke Bernadotte, and her parents, Hiram Edward Manville and his wife, arriving in the United States from Europe on a transatlantic luxury liner. On November 30, 1928, *The New York Times* reported that the upcoming wedding in Pleasantville would be the first time a member of a royal family "will have been married on United States soil." (Courtesy of Carsten Johnson.)

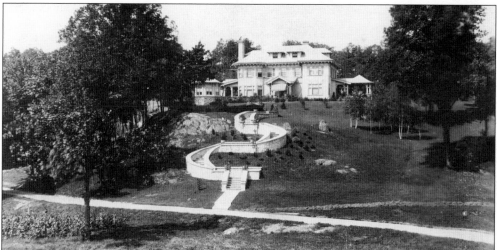

ORIGINAL MANVILLE ESTATE. The Manville family was one of the wealthiest families to settle in Pleasantville. Charles B. Manville, cofounder of the John-Manville Corporation, purchased 150 acres of farmland from Hanna Pierce in 1908. In 1923, his son Hiram Edward Manville built Hi-Esmaro mansion, the site of his daughter's wedding reception.

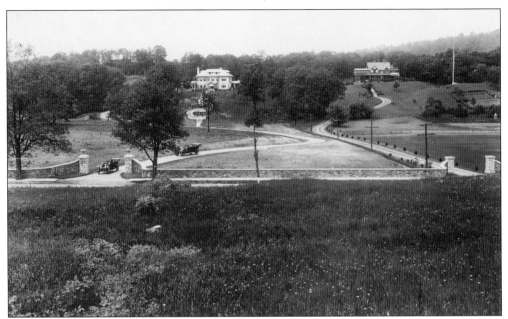

THE MANVILLE ESTATE. The Manville Estate is seen here with the original Manville country home on the right, which was torn down to build the mansion that hosted the December 1, 1928, wedding reception.

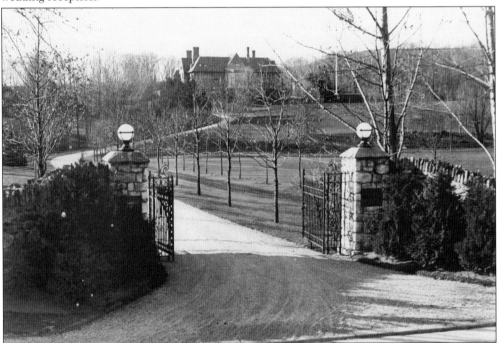

MANSION. Hiram Edward Manville built the new Hi-Esmaro mansion around 1926. Approximately 1,500 guests attended the wedding reception there in 1928. On August 18, 1928, *Time Magazine* published this milestone: "Engaged. Count Folke Bernadotte, nephew of King Gustaf of Sweden; to Estelle Romaine Manville, Manhattan debutante, reportedly a descendant of Jeoffrey de Magnavil, ally of William the Conqueror; in Pleasantville, NY." (Courtesy of Carsten Johnson.)

Six

SCHOOLS

Pleasantville has had a long tradition of excellence in education. The dedication to education has always been a core village value. The initial public schoolhouse in Pleasantville was a small two-story building at Broadway and Church Street. It opened in 1826. The school was eventually moved up Broadway to Old School Lane to accommodate bulging young families. The land for the new schoolhouse was purchased from Benjamin Hays. However, with the arrival of the railroad in 1846 and the subsequent growth of the commuter population, a much larger school was constructed on the grounds of today's Bedford Road School. The year was 1875, and the graduating class reportedly was two. Ultimately, the village elders erected the handsome brick Bedford Road School in 1909, and it housed lower and upper grades. The structure was the pride of the community. Early on, the beloved pioneer of the educational movement in Pleasantville was legendary principal John Morgan. In 1923, the Roselle Avenue School was created to relieve the crowded brick schoolhouse. The Roselle School was home to the kindergarten through fourth-grade students.

Ultimately, the village commissioned a study by Teachers College, Columbia University, in response to the "Need for Further Schools Association of Pleasantville Group." The 1928 report hastened the 1930 construction of the high school at the end of Romer Avenue on land accessible from Sunnyside Avenue and used primarily for village recreational events. The cost of the high school was $500,000. For many years, Pleasantville High School included students from Thornwood, Hawthorne, Armonk, and Briarcliff. Still and all, population growth accelerated, warranting the construction of a junior high school in 1954. It was converted to a middle school in 1966. The expansion continued with an addition to the high school in 1973. However, the high school remained the same until a few years ago whereby an extensive modern upgrade was financed. Today, the Pleasantville Union Free School District remains vibrant under the leadership of superintendent of schools Dr. Mary Fox-Alter. Moreover, Pleasantville's public schools have consistently been ranked amongst the finest in the state.

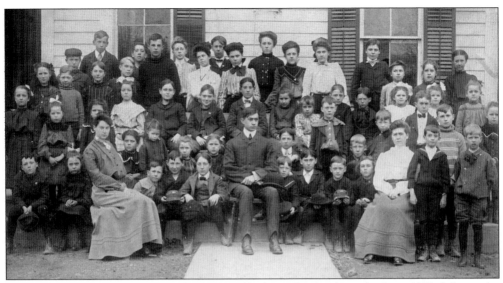

First Bedford Road School. The first Bedford Road School was built in 1875. It housed a grammar school with the primary grades on the first floor and the upper grades on the second floor. This class photograph is from around 1890. (Courtesy of Mount Pleasant Library.)

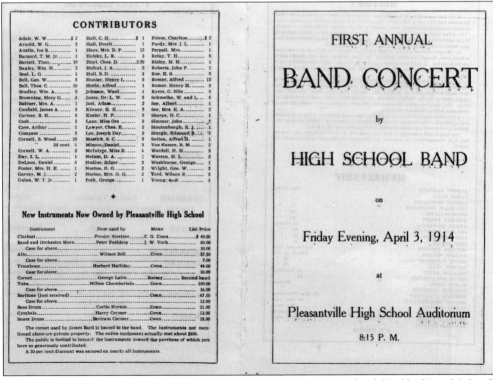

First Band Concert Program One. The first Pleasantville High School (Bedford Road School) was built in 1909 at a cost of $50,000. Principal John E. Morgan and educator Frederick F. Quinlan started the first high school band in 1913. It reportedly was the first in New York State. The inaugural high school band concert was held on Friday, April 3, 1914. This valuable document cites the inventory of instruments and local contributors. (Courtesy of Dorothy A. Perry.)

HISTORY

In the latter part of the last school year, following a rhetorical program in which the school had been led in the singing by a cornet and several violins, a number of interested boys gathered around what seemed to be the center of attraction—a cornet. "This school ought to have an orchestra," "This school should have a band" seemed to be the undebatable questions of the hour. At that time only Albert Barrett and Herman Spahn owned the instruments that are being used to-night.

Mr. Morgan believed heartily in both questions, but having had a short experience in band work, thought the latter would be the most practical and said that he would get them started. A word was enough and soon he was out with a subscription paper (which is yet in existence) and boys indicated their willingness to provide instruments.

An order for nine instruments was placed during the summer vacation and late in September, 1913, the Pleasantville High School Band was organized. About 16 boys were ready to begin work on October 1st. Shortly after this, Harry Marshall, Otto Spohn, Stetson Bender, Carlton Sullivan, Raymond Baker and Franklin Brundage entered. The two silver plated alto horns and the bass trombone were added the last of November, adding three new members.

A few rules, very well lived up to, has been the cause of success, if the word success can be allowed:—The purchase of only high grade instruments; faithful practice; discipline at rehearsals and strict attention to instructions and suggestions.

The band is still somewhat in debt and somewhat in need—uniforms, etc.—but we feel it is accomplishing its purpose, and therefore we beg your co-operation in the future.

MEMBERSHIP

ALBERT BARRETT	Solo Cornet
JAMES BARD	" "
GUSTAV BERGMARK	" "
FRANKLIN BRUNDAGE	1st "
GEORGE LAIRE	1st "
HERMAN SPAHN	1st Clarinet
HARRY MARSHALL	1st "
FRAZIER STRATTON	2d "
JOHN SCHAEFER	2d "
OTTO SPAHN	Piccolo and Flute
STETSON BENDER	Solo or 1st Alto
ERNEST WILCOX	2d "
PETER FANBJERG	3d "
WILMOT BELL	1st Trombone
WILLIAM HUNT	2d "
FLOYD CODDINGTON	Baritone
HARRY GIBBS	
CARLTON SULLIVAN	Bb Bass (Trombone)
HERBERT HALLIDAY	Eb Bass Tuba
MILTON CHAMBERLAIN	Bass Drum
CURTIS NORTON	Cymbals
HARRY CARMER	Snare Drum
RAYMOND BAKER	" "
BERTRAM CARMER	
	J. E. MORGAN

PROGRAM

PART I

QUICKSTEP	Amazon	Ripley
	BAND	
CHORUS	Miller's Wooing	Faning
	HIGH SCHOOL GLEE CLUB	
CORNET SOLO	Killarney	Balfe
	JAMES BARD	
READING	Selected	MISS MABEL MULLINS
ANDANTE AND WALTZ---Daisies		Pettee
	BAND	
VOCAL SOLO	Fay Song	Harry Ware
	MRS. CHARLES BELL	
MARCH	Reunion	Thomas
	BAND	

PART II

SERENADE	Stars are Twinkling	Ripley
Alto Solo, Ernest Wilcox; Cornet Solo, Gustav Bergmark		
Tuba Solo, Milton Chamberlain		
CHORUS	Gypsy Life	Schumann
	HIGH SCHOOL GLEE CLUB	
QUARTETTES		Familiar Selections
READING	Selected	MISS MABEL MULLINS
ANDANTE AND WALTZ---May Day		Dr. H. M. Seem
	BAND	
BARITONE SOLO---The Two Grenadiers		Schumann
	EDWARD S. ROE	
MARCH	The Vigilant	Weiss
	Star Spangled Banner	

PROGRAM TWO. The 1914 high school band concert program provides a history, membership, and listing of performances of this celebrated event. (Courtesy of Dorothy A. Perry.)

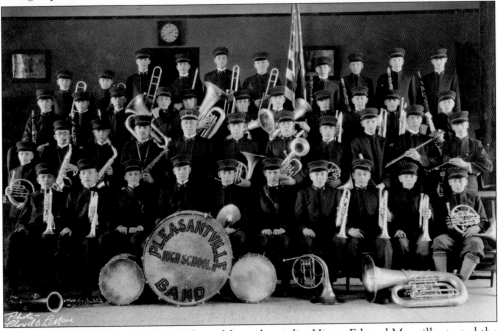

MANVILLE BAND UNIFORMS. In 1935, wealthy industrialist Hiram Edward Manville started the proud tradition of green and white uniforms when he ordered and donated tailor-made custom uniforms for the Pleasantville High School Band at a cost of nearly $2,500. (Courtesy of Mount Pleasant Library.)

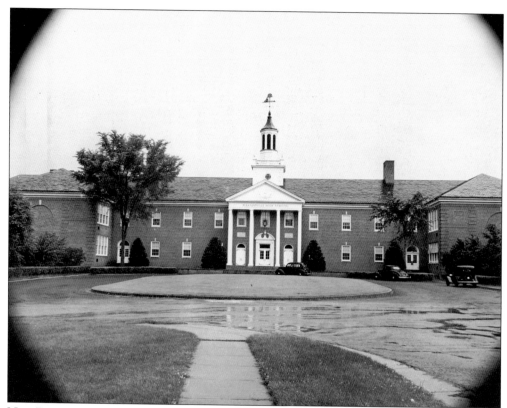

NEW PLEASANTVILLE HIGH SCHOOL. The new Pleasantville High School was built in 1930 at a cost of $500,000, at the end of Romer Avenue on land that had previously been used as a village recreational area. (Courtesy of Mount Pleasant Library.)

GIRLS' FIELD HOCKEY. The Pleasantville High School girls' field hockey program was extremely popular. This photograph is from around 1925. (Courtesy of Mount Pleasant Library.)

MOUNT VERNON. The Pleasantville High School senior class trip to George Washington's mansion and tomb in Mount Vernon, Virginia, took place on March 20, 1931. (Courtesy of Mount Pleasant Library.)

PLEASANTVILLE HIGH SCHOOL FOOTBALL, c. 1920. The Pleasantville High School football team from around 1920 is photographed in front of the World War I monument at the Bedford Road School. (Courtesy of Mount Pleasant Library.)

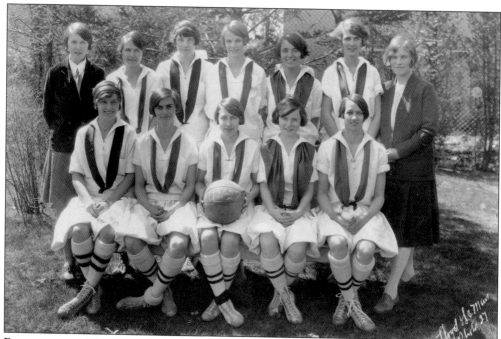

PLEASANTVILLE HIGH SCHOOL GIRLS' BASKETBALL TEAM. This Pleasantville High School 1926–1927 girls' basketball team photograph was taken outside the current Bedford Road School. (Courtesy of Mount Pleasant Library.)

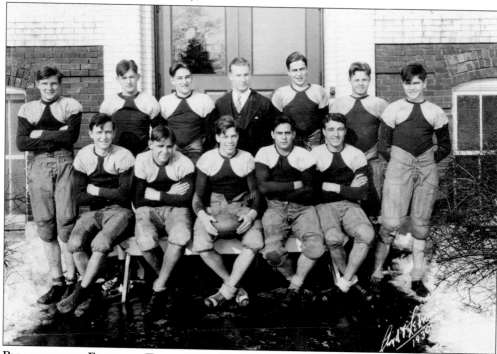

PLEASANTVILLE FOOTBALL TEAM, 1930. This Pleasantville High School 1930 football team photograph was taken on the Academy Street entrance of today's Bedford Road School. (Courtesy of Mount Pleasant Library.)

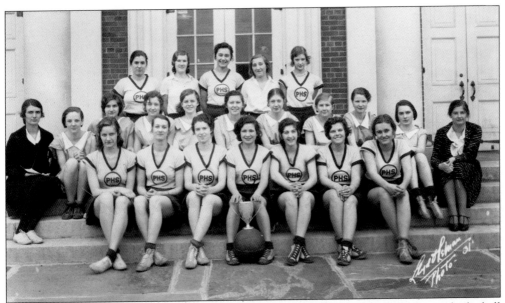

PLEASANTVILLE HIGH SCHOOL GIRLS BASKETBALL TEAM, 1931. The 1930 to 1931 women's basketball team is photographed in front of the newly completed Pleasantville High School. (Courtesy of Mount Pleasant Library.)

LIBRARY HALL. Pictured in 1903 is the Pleasantville Library Hall, which was built in 1896 with funds in part from the sale of cookbooks. It also served the village as a meeting hall and a library reading room. (Courtesy of Fred Higham Jr.)

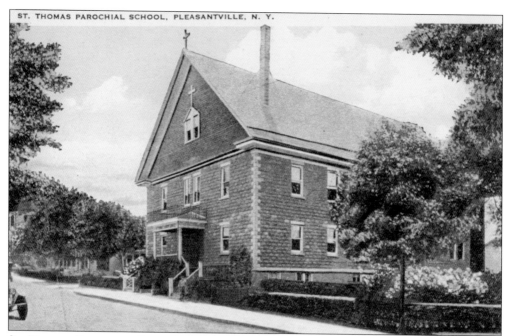

ST. THOMAS PAROCHIAL SCHOOL. St. Thomas Hall was constructed in the shadows of the old Holy Innocents Church in 1908. It was the first parochial school in Mount Pleasant and was located on the corner of Manville Road and Tompkins Avenue. It consisted of six classrooms, a large hall with a stage, and two bowling alleys. Today, the site is the parish parking lot. (Courtesy of Mount Pleasant Historical Society.)

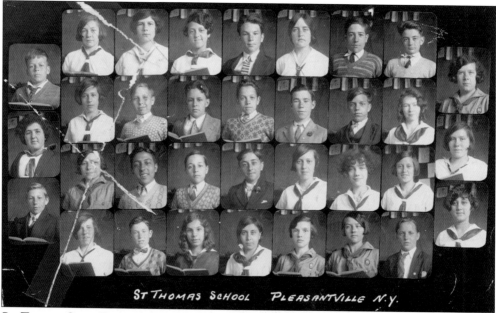

ST. THOMAS CLASS PHOTOGRAPH. St. Thomas Parochial School's seventh- and eighth-grade 1928 class photograph was a source of pride for students and parents. To this day, St. Thomas School graduates boast of the strict academic standards within the classroom and the superior athletic talent on the baseball field. (Courtesy of Ann Cedrone.)

CHOATE HOUSE. The Pace University Choate House located on the old Edward Buckbee farm was built in 1867 by shoemaker Samuel Baker. Thousands of Pleasantville High School graduates have attended and graduated from Pace. Moreover, hundreds of Pace University graduates would eventually settle and raise families in the village of Pleasantville.

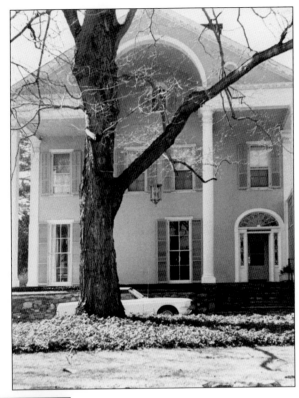

CLARE TREE MAJOR THEATRE. Clare Tree Major, a native of London, founded the children's theater in the giant building constructed on a rock ledge next to the Pleasantville Post Office in 1926. Her nationally acclaimed productions would often play from coast to coast and received the national endorsements of several prestigious academic institutions. Her touring groups included the National Academy of Theatre, which had summer sessions for children and adults, and the National Classic Theatre, a group formed to present Shakespearean and other plays before high schools and colleges. (Courtesy of Pleasantville Archives.)

The

NATIONAL
CLASSIC THEATRE

Presents

"Enough of this — I pray you, hold your peace." Romeo and Juliet

SHAKESPEARE'S

The Merchant of Venice

Macbeth · · Taming of the Shrew

Romeo and Juliet

Director CLARE TREE MAJOR, Pleasantville, New York

CLASSIC THEATRE. The Clare Tree Major National Classic Theatre brought wide acclaim to Pleasantville and provided talented New York City and local actors the ability to further careers off-Broadway. Clare Tree Major conducted her theater operations on Memorial Plaza for 28 years before movies and television brought quality entertainment to the American household. She was also the author of five books and died in 1954. (Courtesy of Pleasantville Archives.)

ALICE IN WONDERLAND. The Clare Tree Major Children's Theatre production of *Alice in Wonderland* was very popular nationally. Other productions included *Peter Pan*, *Heidi*, and *Snow White and the Seven Dwarfs*. The children's theater played across the country as well as in Canada and Mexico. (Courtesy of Pleasantville Archives.)

MARION STRAW. The beautiful Marion Straw starred on Broadway but started her acting career with the Clare Tree Major National Classic Theatre. Clare Tree Major won awards from the American Association of University Women, Boards of Education, Junior Leagues, and other organizations whose members were devoted to the ethical and emotional welfare of children. Sales of tickets for plays brought funds needed for free lunches, milk, dental care, and glasses for underprivileged and neglected children in America. (Courtesy of Pleasantville Archives.)

FLORENCE'S CANDY STORE. Florence's Candy Store was a very popular stop for Pleasantville students after school. It was located at the corner of Bedford Road and Cooley Street, which is currently the site of the Art of Wine. (Courtesy of Pleasantville Archives.)

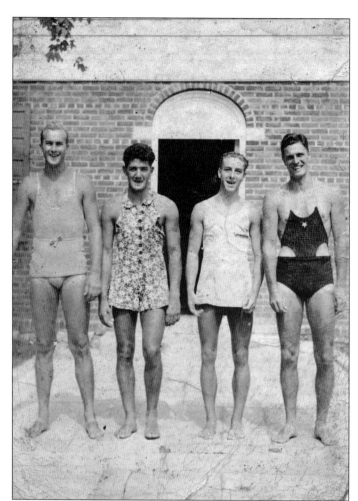

HIGH SCHOOL SENIORS. This 1938 photograph is of four high school seniors "drawing laughs" in female bathing suits at the Pleasantville pool. (Courtesy of Pleasantville Archives.)

CONSTRUCTION. Pictured is construction of old Rebecca Road, now Manville Road, with St. Thomas School on the right. (Courtesy of Pleasantville Archives.)

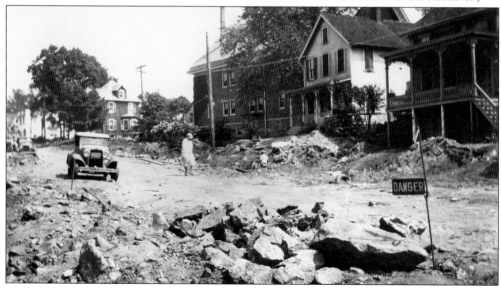

SCHOOL TRUSTEE. Pleasantville school trustee Harry B. MacLaughlin, of 39 Grandview Avenue, won international acclaim when he was chosen as a candidate as "New York's Typical Father" at the 1939 World's Fair. (Courtesy of Pleasantville Archives.)

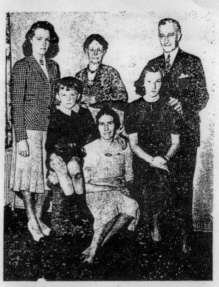

NEWS OF 1939

TYPICAL DAD—Harry B. MacLaughlin, insurance broker and Pleasantville school trustee, was chosen as "New York's Typical Father" at the World's Fair, Sunday, June 18. Standing, left to right in the picture are: Mary Anne MacLaughlin, Mrs. Alice E. Werhams, mother of Mrs. MacLaughlin, and Mr. MacLaughlin. Seated are: Harry, Jr.; Mrs. MacLaughlin and Carol. Andrew, another son, was not present for the picture.

June 15, 1939 PLEASAN

MacLaughlin Candidate for Title of 'Typical Father'

Selection to Be Made Sunday at World's Fair; Mother-in-Law Nominates Pleasantville Man

Harry B. MacLaughlin, of Grandview Avenue, Pleasantville, is one of 12 finalists who will vie for the title of "New York's Typical Father" next Sunday at the World's Fair. Mr. MacLaughlin, a well-known villager, and a member of the Pleasantville Board of Education, was chosen to represent this section from among hundreds of fathers who were nominated in short essays sent by their friends and families.

Mr. MacLaughlin enjoys the distinction of having been nominated by his mother-in-law, Mrs. A. E. Werhan, who stated in her nomination:

"He is amiable, capable, unselfish, old-fashioned in his common sense, cheerful, optimistic, honorable, a straight thinker and never so happy as when in the company of his wife and children."

Mr. MacLaughlin is the father of four children, Andrew, 19, now at Bowdoin College, Mary Ann, 16, Carol, 14 ,and Harry, Jr., 8. He was born in Williamstown, Mass., and is a graduate of Bowdoin. During the World War he was a captain in the Motor Transport Corps. He has been a trustee of the Board of Education of Union Free School District No. 9 for more than two years.

Mr. MacLaughlin and eleven other competitors from the metropolitan area will be at the World's Fair on Father's Day next Sunday when a committee of judges will choose one man as "New York's Typical Father." The winner of the contest will receive a major portion of the awards which include an automobile, clothing and other prizes.

An elaborate entertainment will be staged at the fair in connection with the ceremony. The judging and the show will be held from 4 p. m. to 6 p. m. in the Court of Peace.

FATHER OF YEAR. This June 15, 1939, *Pleasantville Journal* article cites Harry MacLaughlin's honor at the World's Fair was big news in the village. (Courtesy of Pleasantville Archives.)

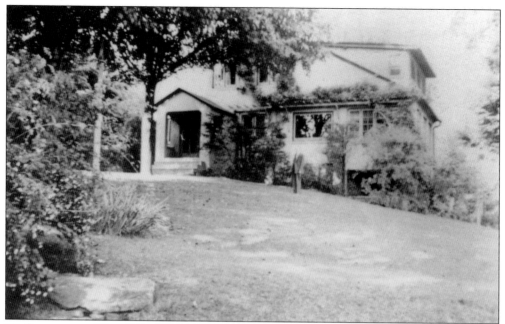

39 GRANDVIEW. This 1911 photograph of 39 Grandview Avenue shows Norwegian shipping executive Mr. Kirchen admiring the construction of his new home. Harry B. MacLaughlin bought the home in 1950.

SCHOOLCHILDREN. The four Kirchen sisters are pictured here at 39 Grandview Avenue in 1917. The youngest girl, Chestine (right), was born in 1911 and graduated from Pleasantville High School. In 1995, she visited Pleasantville with her oldest daughter, who graduated from Harvard.

CHRISTMAS. This image offers a look at festive Pleasantville Christmas decorations in the Kirchen household at 39 Grandview Avenue around 1915.

GARDEN. A photograph of a large, well-tended vegetable garden is seen just outside the Kirchen household at 39 Grandview Avenue.

39 GRANDVIEW. This is a 2012 photograph of how 39 Grandview Avenue fared over a 100-year period. (Courtesy of Douglas Elliman Real Estate.)

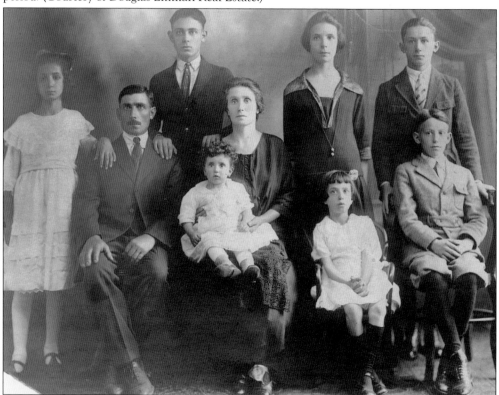

NAPPY. Young Dominic "Nappy" Napolitano grew up in the Flats of Pleasantville. He is seated in the front row in the family photograph with his hands folded on his lap. Nappy would go on to be a lifeguard at the Pleasantville pool and to great fame as an adult at Notre Dame. (Courtesy of the Napolitano family.)

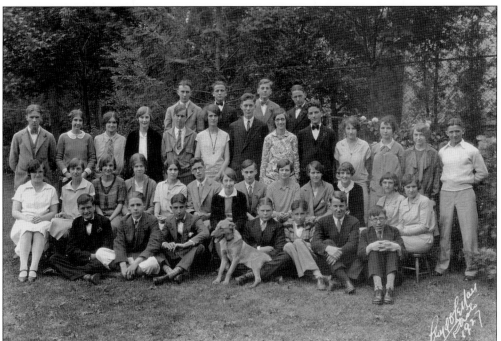

St. Mary's Catholic High School.
Dominic "Nappy" Napolitano attended St. Mary's Catholic High School in Katonah and is shown here standing, far right in the white sweater, with the graduating class of 1927. St. Mary's was founded in 1924. (Courtesy of the Napolitano family.)

Bengal Bouts. Legendary football coach Knute Rockne first organized boxing at Notre Dame in 1920 to raise funds for Holy Cross missions in Bangladesh. Pleasantville native and coach Dominic "Nappy" Napolitano, class of 1932, took over in 1933 and solidified the tradition of sportsmanship and safety for more than 50 years. The Bengal Bouts tradition lives on today at Notre Dame. (Courtesy of the Napolitano family.)

Strong bodies fight, that weak bodies may be nourished —Dominic J. "Nappy" Napolitano, Director Emeritus

NOTRE DAME BENGAL BOUTS
1931 1985

STEPAN CENTER • MARCH 3, 5, 8
QUARTERFINALS: SUNDAY AT 7:30 PM • SEMIFINALS: TUESDAY AT 7:30 PM
FINALS: FRIDAY AT 7:30 PM
ALL PROCEEDS GO TO HOLY CROSS MISSIONS IN BANGLADESH

1995–1996 BASEBALL CHAMPS. Arguably one of the greatest baseball teams in the history of Pleasantville High School, the 1995–1996 squad was Southeast Regional Champions under the careful guidance of head coach Bob Jordon. The 1995–1996 baseball team managed to capture the hearts of Pleasantville, which historically has always been a high school football powerhouse. The other notable Pleasantville High School baseball team was the 1952 SWIAC League Champion under Coach Beattie and featured the dominant pitching of Richard Roth and the impressive .438 batting average of outfielder Rick McCoy. (Courtesy of Bob Jordon.)

Seven

THE FLATS

The Flats has been a fascinating segment of Pleasantville history. The residential area lies in the shadows of the high school. Since inception in the 1880s, it has been a colorful story of immigration from Southern Italy, primarily highly skilled stonecutters who worked on the mighty Nile River's Aswan High Dam in Egypt. The very name "Flats" has long been a subject of considerable debate. One theory for the name was the original owner of the area, a German called Carl Gros (Grossman) had farmed there because it was the only flat terrain in the village. The other theory was that a three-story brick building on Saratoga Avenue constructed in the early 1900s was the largest apartment house in Pleasantville and the primary residence for new Southern Italian and Sicilian families looking for a flat.

The age-old story of supply and demand created the immigration. The early 1880s construction of the Kensico Earthen Dam and the Croton Dam created a dearth of skilled stonecutters and masons. Consequently, Italian "Patronis," or labor contractors, quickly assembled an experienced workforce in Sicily and Sardinia for work in Westchester. The demand exploded in 1913 when work started on the massive Kensico Dam. Ultimately, work on the Kensico Dam in Valhalla was completed in 1917. However, a core group of Sicilian families decided to call the Flats home, and over the next few decades would quickly transform their skills to build remarkable structures throughout the village. Our Lady of Pompeii Church on Saratoga Avenue, the Mount Pleasant Bank on the corner of Wheeler and Bedford Roads, and the Rome Theatre on Manville Road still stand today. In time, the workers fanned out to build mansions for titans of American industry. Our Lady of Pompeii Church was the focal point in the lives of the community members. In 1925, a hall was added so that religious instruction could take place there. The inspiration for the house of worship was Fr. Alexander Mercier, a French Dominican priest who spoke five languages and kindly tended to the spiritual needs of families in the Flats.

German-American Real Estate Title Guarantee Company.

CAPITAL, - - $500,000.

34 NASSAU STREET,
(Mutual Life Building)
NEW YORK.

189 MONTAGUE STREET,
(Real Estate Exchange Building)
BROOKLYN.

Party insured *Carl Grossmann*

Premises *Sherman Park*
Mt. Pleasant
Westchester Co.
N.Y.

No. *6966.*

Amount of Insurance, $ *200 00/100*

A policy to any subsequent purchaser, or mortgagee (subject to conditon 5), at one-third of the original fee, on 48 hours' notice.

Fifth Edition.

CARL GROSSMANN. Louis Smadbeck bought several farms in Thornwood and Hawthorne that reached into Pleasantville and called them Sherman Park. He then formed the Rapid Transit Real Estate Company and German American Real Estate Title Guarantee Company to sell the land and provide insurance of title. Carl Gros ("Grossman") was a German squatter who farmed all of what is commonly called the Flats for years and who was compelled to buy his land with this 1892 deed. (Courtesy of Rubino Family Archives.)

A. GIANNY & C. *Assouan (Alto egitto)*

PANCRAZIO AUCELLO. This photograph is of young Pancrazio Aucello at the Aswan High Dam in Egypt. Aucello left Sicily at the age of 14 to learn the craft of master stonecutter and worked on the 1889 Aswan High Dam construction for years. Afterwards, he migrated to New York to join a small group of highly skilled Southern Italian stonecutters who provided critical segments for the completion of the architecturally acclaimed Kensico Dam in Valhalla. (Courtesy of Rubino Family Archives.)

STONECUTTERS. In 1909, the New York City Board of Water Supply signed a contract to replace the Kensico earthen dam with a new modern structure to meet the growing demands of New York City. More than 1,500 workers labored on the project. This 1914 photograph is of some of the Southern Italian stonecutters who worked at the Kensico Dam and who settled in the Flats in Pleasantville. (Courtesy of Rubino Family Archives.)

APARTMENTS ON SARATOGA AVENUE. The three-story brick structure on Saratoga Avenue provided residence for many Southern Italian families flocking to the area. One theory on how the Flats received its name was because of the level land Carl Gros farmed. The other theory is that this building provided flats or apartments for many new families. The subject has been a topic of debate for years, however, no written record of the designation "Flats" has ever been found. (Courtesy of Rubino Family Archives.)

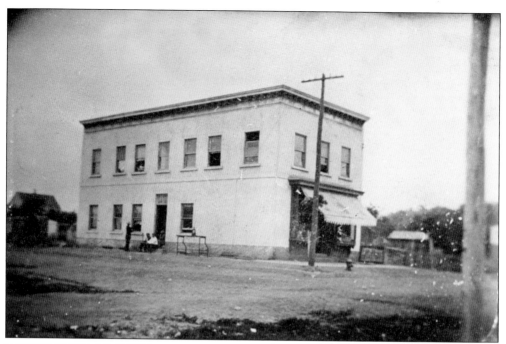

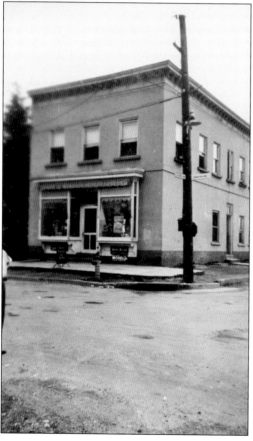

AUCELLO STORE. Pancrazio Aucello purchased this property on the corner of Saratoga and Columbus Avenues from Nick Cristafalo in 1911. Shortly afterwards, his wife, Concetta Aucello, decided to open an Italian grocery store on the first floor of the building. (Courtesy of Rubino Family Archives.)

AUCELLO STORE. Around 1930, the Aucello store thrived in the community for decades. The building also included four apartments. (Courtesy of Rubino Family Archives.)

MANVILLE APARTMENTS. The Italian masons fanned out to build this apartment building on Rebecca Avenue (now Manville Road) around 1910. The year before, masons Rosario Aucello, Leonard Pagano, Salvatore Siciliano, Louis Gullotta, Joseph Cannizzaro, and others built the Mount Pleasant Bank and then rebuilt Holy Innocents Church after it suffered a fire. In 1925, Nicolas Cristafalo built the first municipal building in Pleasantville at 48 Wheeler Avenue at a cost of $63,263. (Courtesy of Rubino Family Archives.)

ROME THEATRE. The beautiful Rome Theatre was built by the Italian masons living in the Flats. This early Rome Theatre program advertising Rudolph Valentino and other coming attractions is testimony of the vibrant cultural growth in Pleasantville. Today, the Rome Theatre is home of the highly acclaimed Jacob Burns Film Center. (Courtesy of Sky Star Jewelry.)

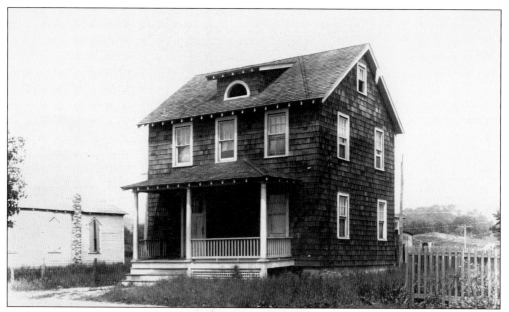

RUBINO HOME. This 1910 photograph of a new construction home on Saratoga Avenue next to Our Lady of Pompeii Church was purchased by Pancrazio Aucello and rented to Pleasantville teachers for decades. (Courtesy of Rubino Family Archives.)

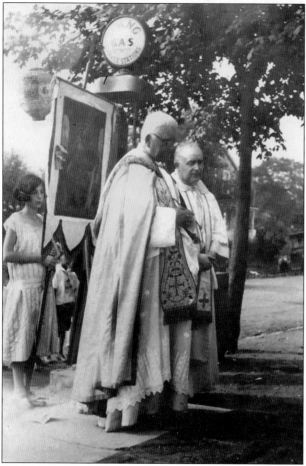

FATHER ALEXANDER BLESSING. The beloved Fr. Alexander Mercier (who spoke five languages) is shown here on Saratoga Avenue blessing an Italian family business in the Flats. (Courtesy of Rubino Family Archives.)

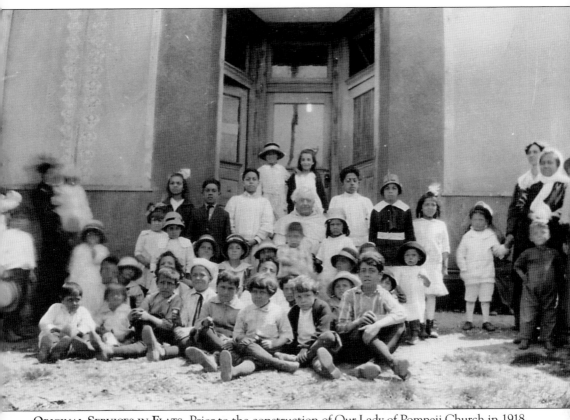

ORIGINAL SERVICES IN FLATS. Prior to the construction of Our Lady of Pompeii Church in 1918, Catholics in the Flats held services at this building on Saratoga Avenue (no longer in existence). Fr. Alexander Mercier is seated here with the many children of Italian families who worshipped under his guidance. (Courtesy of Rubino Family Archives.)

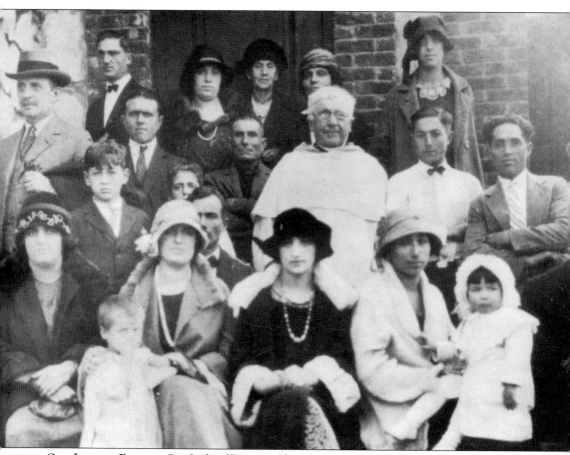

OUR LADY OF POMPEII. Our Lady of Pompeii Church was completed in 1918. In this photograph, Fr. Alexander Mercier is standing among the faithful Italian members of the parish who showered him with affection. (Courtesy of Rubino Family Archives.)

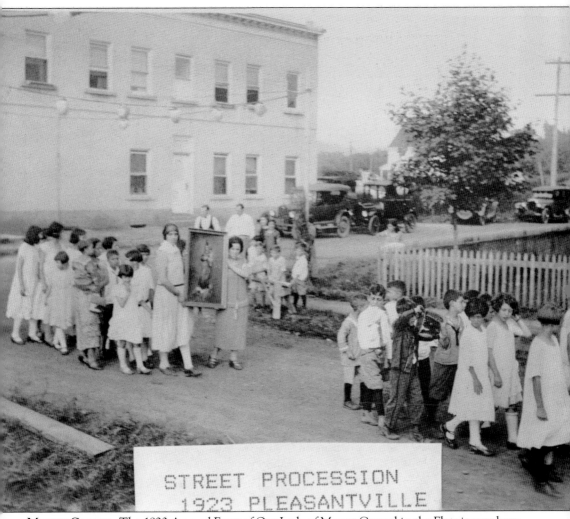

STREET PROCESSION
1923 PLEASANTVILLE

MOUNT CARMEL. The 1923 Annual Feast of Our Lady of Mount Carmel in the Flats is seen here. The bazaar included booths and games with food and prizes. An interesting contest required climbing a greased pole to win a live rooster perched atop the pole; the successful climber won the rooster. (Courtesy of Rubino Family Archives.)

PROCESSION. A c. 1950 photograph is seen here of a formal procession of teenage girls in advance of the Annual Feast of Our Lady of Mount Carmel. In time, many Southern Italian families would move elsewhere, and energy for the annual event waned. The last feast and bazaar took place in the late 1970s. (Courtesy of Ginny Brentano.)

Eight

READER'S DIGEST

DeWitt Wallace and Lila Bell Acheson, the founders of *Reader's Digest*, were married in the Presbyterian Church in Pleasantville on October 15, 1921. However, the modest beginnings of *Reader's Digest* started in New York City's Greenwich Village. One evening in 1922, after leaving a local restaurant, Lila spotted an advertisement for a garage apartment in Pleasantville. She said it was an omen she could not resist. The couple rented the two-story fieldstone building on Eastview Avenue the next day for $25 a month and moved the business. The garage was on the hilltop estate of Pendleton Dudley. Within weeks, they needed more room. DeWitt and Lila hired local girls to help with the growing subscriptions but the very first hire was a lanky young Harvard graduate who grew up in Burma, the son of missionary parents. His name was Ralph Henderson. He immediately settled in Pleasantville and shared the Wallaces' vision that *Reader's Digest* be a wholesome voice for good. The magazine would go on to hire the best and brightest writers and editors in the nation. The business model was to be progressive, to reach out to housewives and working women, and to champion safe driving laws as well as a crusade against smoking.

Subscriptions mushroomed. In the late 1920s, the Wallaces hired the entire Pleasantville Woman's Club to help keep up with subscriptions. It was not enough. In 1930, they hired 200 women to meet demand. By 1936, the Wallaces rented 14 different Pleasantville properties and had an editorial staff of 32 working long hours. Parking in Pleasantville was scarce. As a result, Pleasantville police wrote out a total of $60 a day in fines to *Reader's Digest* employees who parked wherever they could to get to work on time. Eventually, DeWitt approached the leadership of Pleasantville to build an elegant headquarters campus in the village. Unfortunately, they rejected his request saying they did not want industry in the village. As he left the meeting he told them, "You will live to regret this day." In 1939, *Reader's Digest* moved to nearby Chappaqua but kept the Pleasantville address because it was reportedly cherished by subscribers.

EASTVIEW AVENUE BEGINNING. This tiny cottage on Eastview Avenue on the property of Pendleton Dudley was the humble beginnings of *Reader's Digest* in Pleasantville. DeWitt Wallace and Lila Bell Acheson, the founders of *Reader's Digest*, were married in the Presbyterian Church in Pleasantville on October 15, 1921, but actually started the production of *Reader's Digest* in Greenwich Village in February 1922. They quickly ran out of room and rented this two-story fieldstone building for $25 a month. (Courtesy of Pleasantville Village Archives.)

READER'S DIGEST. *Reader's Digest* thrived when the Wallaces opened for business in Pleasantville. The magazine would go on to hire the best and brightest writers and editors in the nation. The Wallaces were also mindful of hiring as many Pleasantville residents as possible and renting space in the village. In 1925, the Wallaces bought land next to Pendleton Dudley on Eastview and built a home and office in a long, low Normandy house with a colored tile roof. (Courtesy of Fred Higham.)

CHAPPAQUA. *Reader's Digest* overflowed to 14 separate and crowded offices in Pleasantville by 1936. The magazine reflected the progressive characteristics, tastes, and opinions of DeWitt and Lila Wallace. It appealed to a fast-moving, fact-hungry, post–World War generation. However, DeWitt's vision of building his world headquarters in the village he cherished was rejected by Pleasantville leaders, and he was forced to build the elegant campus in Chappaqua in 1939. (Courtesy of Fred Higham.)

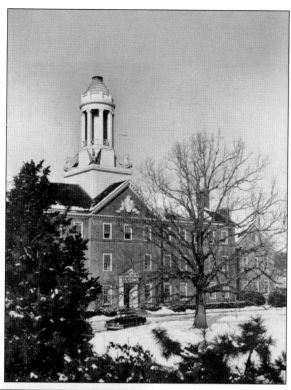

WORLDWIDE. "The Little Magazine," which *Reader's Digest* was often called would grow to 30 editions in 14 languages with a world circulation of 28 million a month by 1967. The Wallaces chose editors with great care. They brought professionals who shared or reflected their own idealism, humor, and faith in human nature. Eventually, the Wallaces built a publishing empire, which they believed to be a force for good throughout the world. (Courtesy of Fred Higham.)

DeWitt Wallace. At a White House dinner in honor of the 50th anniversary of *Reader's Digest* on January 28, 1972, Pres. Richard Nixon awarded the Medal of Freedom to DeWitt and Lila Wallace. Nixon said, "I was thinking of what the *Digest* stands for, loyal readership with a circulation of 29 million of course, but I think what the *Digest* means and stands for is for God, for country, and for the joy of life." (Courtesy of Fred Higham.)

November 12, 1889 — March 30, 1981

Lila Wallace. Early on, Lila Wallace convinced her husband, DeWitt, that their magazine would appeal more to women, restless housewives, and newly liberated working women than to men. The first issue aimed at women was called "Untying the Apron Strings." The Wallaces were also advocates for good health and were antismokers during a time when the nation loved cigarettes. They were also concerned with safety in the workplace as well as the importance of sound driving habits. (Courtesy of Fred Higham.)

December 25, 1889 — May 8, 1984

60TH ANNIVERSARY.
This *Reader's Digest* 60th
anniversary publication
is a fine historical
collage of photographs
honoring the memory
of "The Little
Magazine." (Courtesy
of Ann Cedrone.)

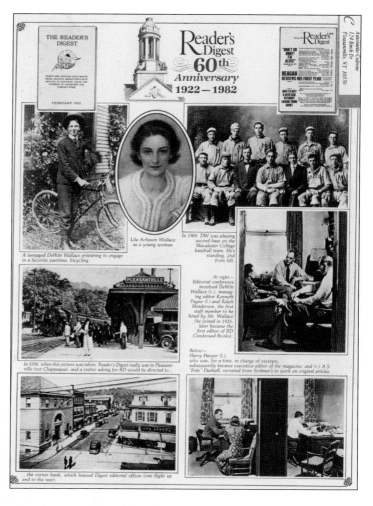

PRIME MINISTER OF JAPAN. This March 1, 1956, *Reader's Digest* advertisement of Japanese prime minister Ichiro Hatoyama's endorsement with a curtain-raiser of new articles is an excellent testimony of the progressive nature of the magazine. The articles in this advertisement include how to conquer frustration, how much debt one can afford, why doctors smoke, and the topic that American men are lousy fathers—cutting-edge pieces for the 1956 generation of American women and men. (Courtesy of Fred Higham.)

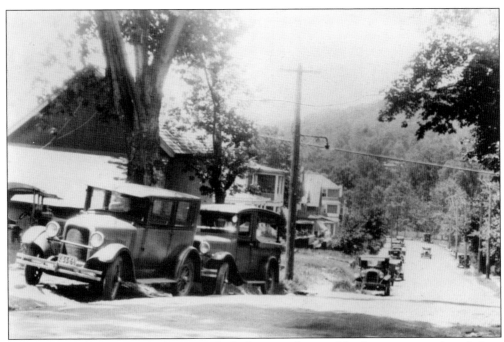

PARKING. *Reader's Digest* employees parked wherever they could, often getting ticketed. As a result, Pleasantville police wrote out a total of $60 a day in fines to *Reader's Digest* employees in 1936. (Courtesy of Pleasantville Archives.)

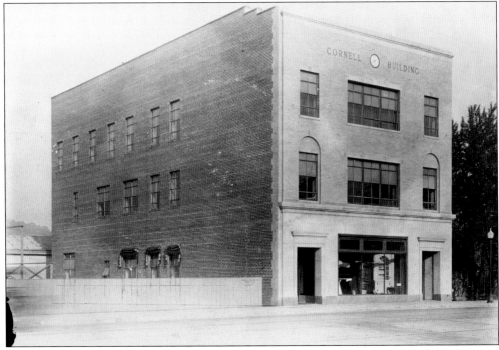

THE OLD CORNELL BUILDING. The old Cornell Building on Memorial Plaza burned down next to the empty lot that would soon be the new, enlarged Pleasantville Post Office and was rebuilt to accommodate the massive mail from the *Reader's Digest*. (Courtesy of Pleasantville Archives.)

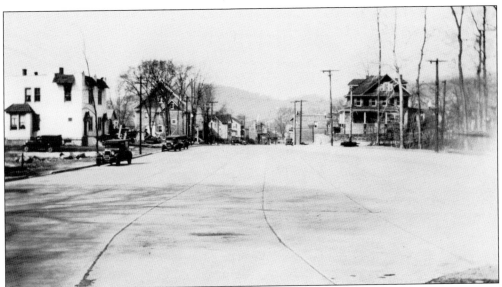

REBECCA ROAD. Pictured is Rebecca Road (now Manville Road) on a quiet Sunday morning around 1936. Pleasantville still had plenty of room for growth with several parcels available in the heart of the village, which attracted many *Reader's Digest* professionals from across the nation to establish roots in Pleasantville. (Courtesy of Pleasantville Archives.)

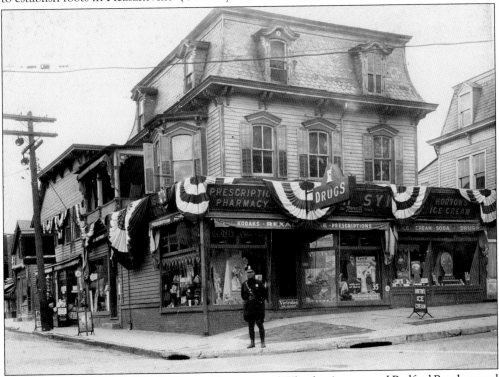

WHEELER AVENUE AND BEDFORD ROAD. The corner of Wheeler Avenue and Bedford Road around 1936 is pictured, complete with new sidewalks and Joseph Sykora's Pleasantville Pharmacy, which reportedly did enormous business with *Reader's Digest* employees across the street. (Courtesy of Pleasantville Archives.)

ORBAEK FARM. The Orbaek Farm Dairy was owned by Michael Mikkelson and operated on Lake Street. He opened his business in 1922 and named it after the town he came from in Denmark. This photograph shows the fleet of trucks that delivered milk, chocolate milk, eggs, butter, yogurt, and cottage cheese during the 1930s. Many New York City commuters to *Reader's Digest* reportedly often returned home with fresh Pleasantville dairy products from Orbaek Farm Dairy. (Courtesy of Phebe Holden Washburn.)

NEW CONSTRUCTION. The Roaring Twenties offered the nation great prosperity and new disposable income. This photograph is new construction that was a result of the growing appeal of Pleasantville as a wholesome family community and the job opportunities at *Reader's Digest.*

Nine

THE WAR YEARS

Pleasantville has an impressive history of wartime activities on the home front. However, it must not be overlooked that large segments of the community were not inclined to enter the European conflict during World Word I. Nonintervention was strong. Village residents preferred avoiding the horrific conditions in the French trenches and, for the large part, hoped Pres. Woodrow Wilson would broker a peace treaty. It was not that "Pleasantville was too proud to fight," according to archives . . . it was more a situation where life was good across America and the majority was of the opinion that the struggle abroad was not an imminent threat to the country's borders. Nevertheless, the German sinking of American passenger ships dragged the nation into war and true to its colors, the young men and women of the village answered the nation's call to duty. A primary outgrowth of World War I in Pleasantville was the organization of the American Legion. To this end, the Fancher Nicoll American Legion in Pleasantville was one of the first posts in the United States.

The home front during World War II was heroic. Pearl Harbor galvanized Pleasantville. Nearly 850 county volunteer cards, complete with the bearer's photograph, thumbprints, general description, and signature, were issued by the Pleasantville War Council. The Fancher Nicoll American Legion Post 77 went into action 11 months before Pearl Harbor, with its members being tested 24-hours-per-day, seven-days-a-week on their ability to spot every plane in the sky over Pleasantville and report it correctly. There were 1,000 Victory Gardens, and high school girls tended to babies so mothers could work in Tarrytown war plants. War Bond drives and collections for the Red Cross and the USO were immensely successful. The Pleasantville Fire Department played a critical role throughout the war, filling in for the depleted workforce and assisting the emergency medical group under Dr. Maguire and Dr. Wilcox. By bicycle, car, ambulance, and truck, they assisted first-aiders and worked closely with Police Chief Kenneth Romaine, taking courses to defuse unexploded bombs. Lastly, the disaster prevention group missioned with the houses of worship to coordinate strategic sheltering and feeding.

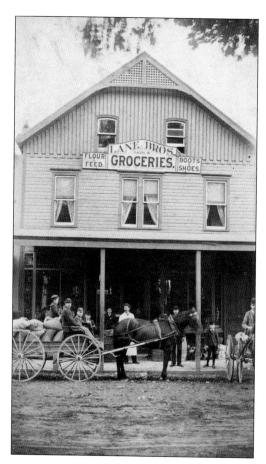

LANE BROTHERS GROCERIES. Prior to World War I, Pleasantville had earthen roads, and horses and carriages were the transportation of the day. Lane Brothers Groceries was a major store in the village and attracted business from all over Mount Pleasant. (Courtesy of Pleasantville Archives.)

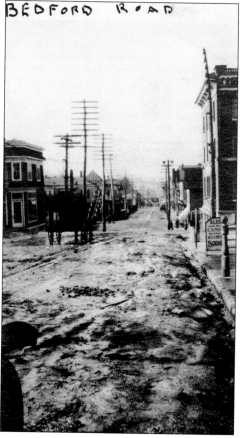

OLD DIRT BEDFORD ROAD. This c. 1910 photograph of Bedford Road is seen here with the newly constructed Mount Pleasant Bank at 80 Wheeler Avenue on the right (the present building at 80 Wheeler was constructed in 1926). The assassination of Archduke Franz Ferdinand of Austria on June 28, 1914, would trigger a great struggle of European powers that Pleasantville residents wanted no part of, according to local news reports. (Courtesy of Pleasantville Archives.)

ITALIAN ANTI-KAISER POSTCARD. This extremely rare, hand-drawn, World War I, Italian anti-Kaiser postcard sent from Italy summed up what Southern Italians thought of the conflict. (Courtesy of Rubino Family Archives.)

FANCHER NICOLL. Shown is the obituary of Capt. Fancher Nicoll, commander of Company I, 3rd Battalion, 107th US Infantry, in the *New York Times* on November 6, 1918. Nicoll lived on Hardscrabble Road in Pleasantville with his wife, Marie Christine, and two children, Julie and John. He grew up in New York City, attended the Collegiate School, went to Williams College, and graduated from Columbia University Law. Returning Pleasantville World War I veterans named the village American Legion Post in his honor. (Courtesy of Pleasantville Fancher Nicoll, American Legion Post 77.)

101

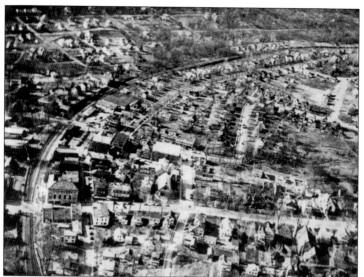

AERIAL VIEW OF
PLEASANTVILLE. Shown
is an aerial view of
the railroad tracks in
village of Pleasantville
before the construction
of Memorial Plaza in
1929. (Courtesy of
Pleasantville Archives.)

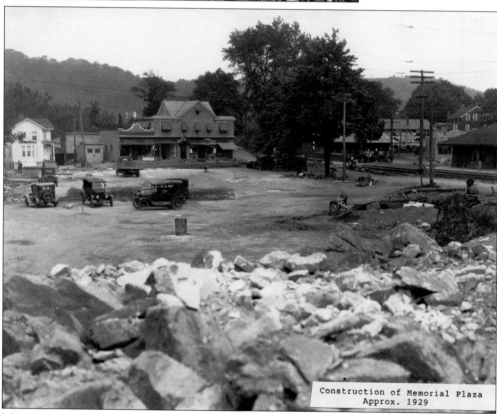

Construction of Memorial Plaza
Approx. 1929

MEMORIAL PLAZA. The 1929 construction of Memorial Plaza, launched by the leadership of
the Fancher Nicoll American Legion Post 77 in conjunction with the mayor's office, advanced
dramatically with the generous gifting of land by the Cornell Lumber Company. The official
dedication of Memorial Plaza took place on Memorial Day 1930. Note in the center background,
the original Pleasantville Masonic Lodge Community House (built in 1922) was to the right of
the newly relocated Lane, Eaton, and Smith offices. (Courtesy of Pleasantville Archives.)

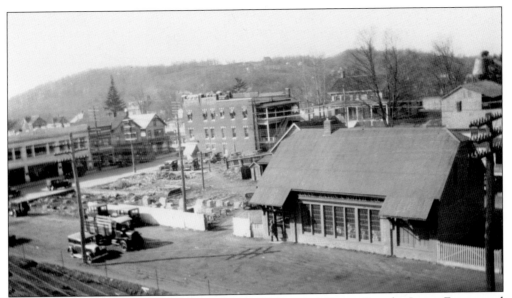

MEMORIAL PLAZA. Pictured is construction of Memorial Plaza after the Lane, Eaton, and Smith building was burned down. The World War II honor roll in Memorial Plaza took place on May 30, 1950. Note the Bedford Road Bells store on far left of the photograph. (Courtesy of Pleasantville Archives.)

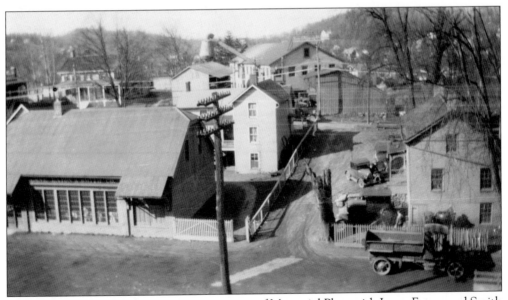

MEMORIAL PLAZA. Seen here is preconstruction of Memorial Plaza with Lane, Eaton, and Smith Company on the left, a Cornell coal delivery truck in the front right, and the Cornell Lumber Company in the background with the giant chute connecting to the main building. (Courtesy of Pleasantville Archives.)

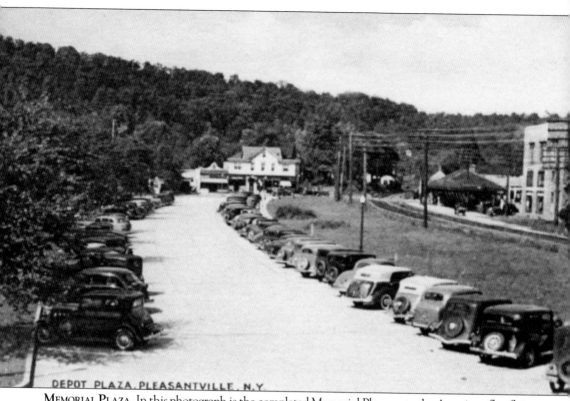

DEPOT PLAZA, PLEASANTVILLE, N.Y.

MEMORIAL PLAZA. In this photograph is the completed Memorial Plaza; note the American flag flying among the trees on the left and the Pleasantville Train Station on the right. For years, some residents called Memorial Plaza by its old name "Depot Plaza." Coincidentally, some residents still incorrectly call the band shell in Memorial Plaza "the Gazebo." (Courtesy of Pleasantville Archives.)

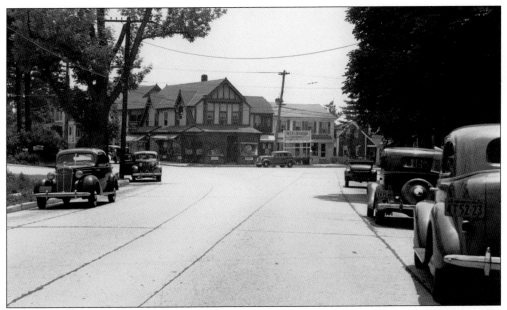

THE OLD VILLAGE. The Old Village in the early 1930s, with the legendary Pleasantville General Store in the far center and W.E. Dodd Realtors to its right, is seen here. (Courtesy of Pleasantville Archives.)

WORLD WAR II DRAFT. On December 7, 1941, Japan attacked Pearl Harbor triggering World War II. However, the United States was already preparing for war; this photograph is of the June 1941 draftees waiting to board the southbound train to New York City for induction to the armed forces. On the far left standing with his arms at his side in a light suit and stripped tie is tall, handsome Pleasantville resident Gordon A. Perry of 40 Weskora Road. (Courtesy of Dorothy Perry.)

PHILIP A. LEE. Joseph and Abby H. Lee of Mountain Road in Pleasantville had four sons answer the nation's call to duty in World War II. Lt. Col. Joseph Day Lee Jr. (33), Lt. Howell Lee (30), Lt. John Barnsdall Lee (27), and 2nd Lt. Philip A. Lee (22), the fighter pilot seen in this photograph. Philip was a graduate of Dartmouth College and the only Lee to pay the ultimate sacrifice for his nation. (Courtesy of Pleasantville Archives.)

CHIPS. Chips, a World War II Army K-9 Corps dog, born and raised in Pleasantville by Mr. and Mrs. Edward J. Wren of Orchard Street, was the first canine to receive the Distinguished Service Cross for heroism on the field of battle. During the course of the war, Chips was honored by Pres. Franklin D. Roosevelt, Prime Minister Winston Churchill, and Gen. Dwight Eisenhower. (Courtesy of Pleasantville Archives.)

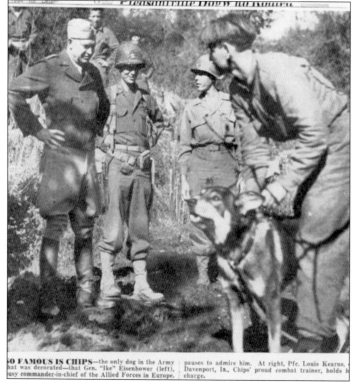

O FAMOUS IS CHIPS—the only dog in the Army that was decorated—that Gen. "Ike" Eisenhower (left), usy commander-in-chief of the Allied Forces in Europe. pauses to admire him. At right, Pfc. Louis Kearns, Davenport, Ia., Chips' proud combat trainer, holds h charge.

CHIPS. The *Pleasantville Journal* account of Chips's World War II heroism in the European theater is seen here. Chips returned to the Wren family after the war ended. (Courtesy of Pleasantville Archives.)

'Chips' of Pleasantville Wins First DSC Awarded Army Dog

PLEASANTVILLE — Chips, a three-year-old mixture of collie, shepherd and huskie, is the first dog in United States military history to receive the Distinguished Service Cross.

The Army hero is owned by Mr. and Mrs. Edward J. Wren of 26 Orchard Street. Announcement of the award was made yesterday by Dogs for Defense, the Army's canine recruiting agency.

Chips won the medal, one of three he has earned, for "courageous action in single-handedly eliminating a dangerous machine-gun nest and causing surrender of its crew." The incident occurred July 10 during the Sicily invasion. He hit the beach with Private John R. Rowell holding his leash. Concealed enemy gunners opened fire from a pillbox camouflaged as a peasant's hut.

Chips was released and darted forward into the hut. One Italian gunner ran out with Chips at his throat and the others, overcome by fear, followed with their hands over their heads.

During the melee Chips was wounded and received the Purple Heart. He recovered and later won the Silver Star.

Chips received the DSC from Major General Lucian K. Truscott.

Chips is reported to have met President Roosevelt, Prime Minister Churchill and General Eisenhower, and is said to be anxious to meet Hitler, with no holds barred.

Pleasantville Italian Gun

PLEASANTVILLE—For ro[...] an Italian pillbox gun crew d[...] the invasion of Sicily, Chip[...] Army dog, once the pet of the[...] ward J. Wren household, a[...] nine-year-old Gail in partic[...] has been recommended for[...] Distinguished Service Cross[...] family announced today.

On the night of the inv[...] Chips was accompanying a s[...] ashore. A machine gun o[...] fire. Chips, who according t[...] ficial citations "was acting en[...] on his own instinct," attacked[...] enemy crew later surrender[...] the sentry.

Part husky and part o[...] "nothing but a grand mutt, re[...] as Mrs. Wren explains. Chip[...] given to Gail when he was a p[...]

EIGHT PLEASANTVILLE SERVICEMEN IN PACIFIC. Pictured is a truly extraordinary meeting of eight Pleasantville Village servicemen during World War II in the South Pacific theater. From left to right are (first row) Sgt. Gordon Washburn, Sgt. Frank Cilonax, and T-4 Angelo Ventura; (standing) Seabee Joseph E. Doyle, Lt. Ulysses Varese, SSgt. Richard Sheridan, and Seabee Andy Hasselbauer. The eighth member of Pleasantville, PFC Gerald J. Smith, arrived too late for this official US Navy photograph. (Courtesy of Pleasantville Archives.)

Special Christmas Edition for Pleasantville Men in Service

Pleasantville Journal

PLEASANTVILLE, N. Y., FRIDAY, DECEMBER 25, 1942

Christmas Greetings from Home

The Village is going to seem mighty lonely this Christmas without you boys, but we know that wherever you are you're in their battling so that the thought and spirit of Christmas will remain alive on this earth.

Just to let you know that we are thinking of you and that our hearts are with you on this day, we are sending you this little Christmas remembrance. We thought you might like to know something of the whereabouts and activities of your old friends and neighbors in Pleasantville, who, like you, have also donned the uniform of Uncle Sam.

Pleasantville is proud of you boys and proud of the work you are doing, and we here on the home front are doing our best to back you up to the limit. During October we collected over 160 tons of scrap metal, more than 45 tons over our quota, so that you will be kept supplied with guns, ships, planes, tanks and ammunition. All of us are subscribing regularly to the purchase of War Bonds and Stamps so that

America will have the funds to carry on this great struggle to final victory.

And you don't have to worry about the safety of your loved ones back home, either. Under our local War Council we have built up a civilian protection system of which we are all justly proud, and we have had frequent practice mobilizations and test blackouts and alerts in order to make sure that everything is functioning properly.

Some 300 of us have given our blood to the Red Cross for the manufacture of life-saving blood plasma for our fighting men. We hope that you will never have need for it, but if you do, you will know that we have not failed you.

Our love and our fondest hopes accompany this little Christmas greeting. Of final victory in this great struggle for freedom we have no doubt. Our prayers are only that it will be quick and sure and for your safe return.

(Signed) Civilian Defense Volunteer Office

ALEXANDER, STANLEY F.: No information available. Please send news.
ALLISON, ALDEN R.: In the service but no news available. Send us information. Christmas greetings. Are you in Army or Navy?
ANDREWS, RICHARD: Second

February, '42. Overseas four months. Now U. S. A. Recently promoted First Lieutenant.
BASILE, FRANK D.: Frank is in an ordnance school in the South.
BASKETT, PERCY: Private— Attached to Infantry now encamped in the South.

Camp Edwards, Mass. Dearest: Here's hoping you're in excellent condition. Wishing you best of luck.

Your wife,
Margie.
BOLAND, CHARLES: No information available. Where are you and what are you doing?
CADMAN, GEORGE: Lieut.

very much missed. Greetings and best wishes.
BURRHILL, DAVID M.: Second Lieutenant Signal Corps—Dave is getting more training outside this country. Greetings from Pleasantville.

CAPPELL, HOWARD N.: Captain, U. S. A. Air Corps—In charge of classification Technical Training Command. Greetings from Pleasantville.
CARLSON, OSCAR T.: U. S. Army—Enlisted Labor Day, mechanic division. Has been sworn in. Waiting to be called

SPECIAL CHRISTMAS EDITION. This is a special December 25, 1942, Christmas edition of the *Pleasantville Journal* with a compassionate and patriotic message to the men and women of the village who answered the nation's call to duty. The special edition also included a list of every member of Pleasantville in the armed forces. (Courtesy of the Pleasantville Fancher Nicoll American Legion Post 77.)

"I pledge allegiance to the Flag of the United States of America and to the republic for which it stands, one nation under God, indivisible, with liberty and justice for all."

Pleasantville Journal

OFFICIAL NEWSPAPER OF THE VILLAGE OF PLEASANTVILLE AND THE TOWN OF MOUNT PLEASANT

Only Newspaper Printed, Published in Pleasantville, serving an area of 15,000 in Pleasantville, Town of Mt. Pleasant, Chappaqua, Briarcliff

68TH YEAR — NO. 17 PLEASANTVILLE, NEW YORK, THURSDAY, FEBRUARY 3, 1955 PRICE FIVE CENTS

Set Interfaith Convocation

The Cub Scouts of Pleasantville for the second year will usher in the 45th anniversary of Boy Scout Week with an Inter-Faith Convocation Sunday, Feb. 6 at 4 p. m. in the Roselle Ave. School.

This year's theme will be "Cub Scout Promise" to be discussed by a representative of each of the Protestant, Catholic and Jewish faiths namely: The Rev. J. R. Hart of the Pleasantville Presbyterian Church; The Rev. Richard L. Clifford, M. M., of Maryknoll Seminary, Ossining and Rabbi Solomon Kaplan of Temple Beth El, Chappaqua.

The program will start with a Cub flag ceremony. The public is cordially invited.

Armisto's Open

LOCAL WOMAN MARINE PROMOTED

WOMAN MARINE 1ST LT. ELLEN B. MORONEY, daughter of Postmaster and Mrs. James J. Moroney of 908 Bedford Road, is promoted to her present rank Dec. 7, 1954 while serving as a Supply Officer at the Marine Corps Schools at Quantico, Va. Lt. Col. E. A. Law presents 1st Lt. Moroney her new commission. Before entering the service in June, 1953, she was graduated from the College of St. Mary of the Springs, Columbus, Ohio.

ROLLING ALONG

Ambulance Corps answered the following calls recently: Jan. 13, Grasslands, medical treatment; 13, to Northern Westchester Hospital, fratured hip; 14, rendered assistance at Lincoln Ave. fire; 24, transportation from NW Hospital to home; 25, NW Hospital, broken hip; 29, NW Hospital, internal bleeding; 31, NW Hospital, fractured arm; 31, special call, stood by for 1st aid; Feb. 1, transportation to hospital.

Two Clubs Unite For Holiday Ball

At a meeting of the Executive Board of the Contemporary Club of Pleasantville, held Tuesday evening, at the home of Mrs. Fenton Rote, 596 Manville Road,

Ambulance Fund Drive Opens Feb. 4

The Fund Drive of the Pleasantville Ambulance Corps will commence Feb 4th. The drive will be carried out by use of simplified mail as in the past. There will be no house-to-house canvass.

The Ambulance Corps gives free first aid service and emergency transportation twenty-four hours a day to about 2600 families in the area. It is urgently requested that a small donation be made by all to meet the fixed budget and replacement fund of the Ambulance Corps.

Albert Ripley is special treasurer of the Fund Drive and all checks should be made out to the Pleasantville Ambulance

1ST LT. ELLEN MORONEY. Seen here is the *Pleasantville Journal* account of US Marine Corps 1st Lt. Ellen B. Moroney's promotion. Ellen was the daughter of Pleasantville postmaster James Moroney and sister of Anne Moroney, who lives in Foxwood. (Courtesy of the Pleasantville Fancher Nicoll American Legion Post 77.)

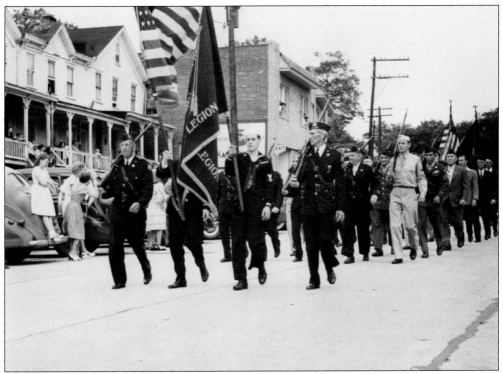

WAR OVER. The war is over. This photograph is of the Pleasantville Fancher Nicoll American Legion Post 77 marching on Manville during the 50th Anniversary of Pleasantville on Memorial Day in 1947. (Courtesy of the Pleasantville Fancher Nicoll American Legion Post 77.)

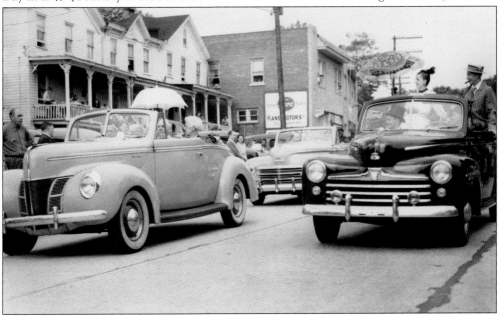

PARADE. Open cars are seen here during the 50th anniversary of Pleasantville on Memorial Day 1947. Witnesses said it was the largest parade in the history of the village. (Courtesy of Pleasantville Archives.)

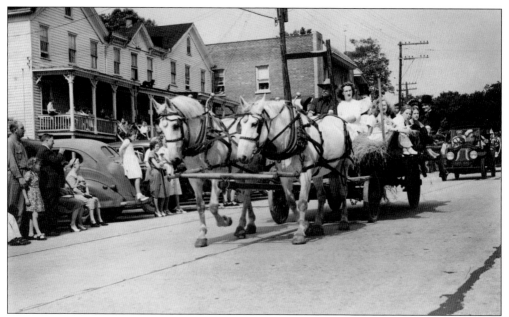

PARADE. Pleasantville was no longer a farming community in 1947, but many farms still existed. This photograph shows local farm horses pulling hay and girls at the 50th anniversary of Pleasantville on Memorial Day in 1947. (Courtesy of Pleasantville Archives.)

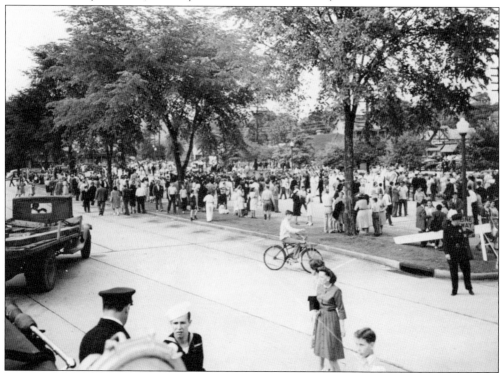

MEMORIAL PLAZA. Here is a view of Memorial Plaza festivities during the 50th anniversary of Pleasantville on Memorial Day in 1947. News reports indicated nearly 2,000 people attended the ceremony. (Courtesy of Pleasantville Archives.)

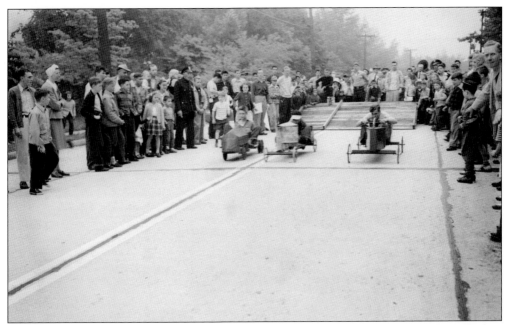

DERBY. Race car derby was a popular activity in Pleasantville in the 1950s. This photograph is of three contestants testing their handmade race cars at Memorial Plaza around 1950. (Courtesy of Pleasantville Archives.)

THE RAIL. The Brass Rail on Washington Avenue was an immensely popular Pleasantville nightclub. It opened on March 1, 1933, and was often frequented by New York City celebrities. The Rail was owned by Dick Devine Sr. and Al Ripley. (Courtesy of Pleasantville Archives.)

DICK DEVINE SR. The Pleasantville Fancher Nicoll American Legion Post 77 marches on Bedford Road around 1950. Dick Devine Sr., co-owner of the Brass Rail, is the man with the white hair, wearing a light sports jacket and a dark shirt with his hands in his pocket, watching from far left. (Courtesy of Pleasantville Archives.)

AL RIPLEY. Al Ripley, co-owner of the Brass Rail (with his hat on and his hands in his pockets), is photographed passing Kings Crown Wines and Liquors on Manville Road. Dick Devine Sr. and Al Ripley were heavily involved in community affairs and would often host amateur boxing matches behind the Brass Rail. (Courtesy of Dianne Ripley.)

Ten

MODERN PLEASANTVILLE

One of the best-kept secrets of Pleasantville was a quiet company that settled in the village and undoubtedly played a decisive role in the protection of this great nation. The name of the concern was General Precision. It belonged to the Kearfott Division of the Singer Company and collaborated with scientists at the Massachusetts Institute of Technology to safeguard America from its enemies. General Precision developed ultra-top secret electronic listening devices that were of utmost importance to the Central Intelligence Agency throughout the Cold War. Moreover, the concern helped develop highly classified electronic and metallic sensor devices that would limit the deployment of the military foot soldier during the Vietnam War. General Precision bought the Manville Estate in January 1946 and would eventually revolutionize electronic navigation systems for the AH-1S Cobra, AH-64A Apache, UH-1H Iroquois, CH-47D Chinook, and UH-60A Black Hawk helicopters. The huge scientific advances in Pleasantville allowed the United States to dominate military and intelligence community technology for decades and also provided the American people with state-of-the-art electronic security across the homeland.

Pleasantville has always been proud of its relationship with Pace University. Classes started on the Pleasantville campus in 1963 after Wayne Marks, chairman of General Foods, generously donated his property to the thriving New York City educational institution. Over the decades, thousands of talented Pleasantville High School graduates went to the beautiful Pace campus and marched off with degrees, prepared to meet the rigorous challenges of a modern workforce. The Girl Scouts Heart of the Hudson, headquartered in Pleasantville, has also played a strong role in the village by helping girls build courage, confidence, and character in order to make the world a better place. Located in the old St. Thomas School, the Girl Scouts Heart of the Hudson provides the administrative leadership for Westchester, Putnam, Dutchess, Orange, and Rockland Counties. Ultimately, the village of Pleasantville is all the name implies. From the beginning right into this new century the legendary residents of this wholesome community has nurtured a tradition of decency, charity, and patriotism that has stood the test of time.

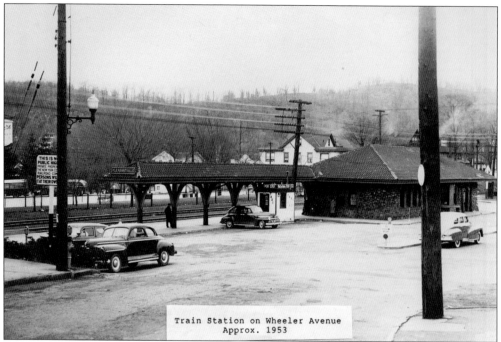

Train Station on Wheeler Avenue
Approx. 1953

TRAIN STATION, C. 1953. This photograph is of the Pleasantville train station around 1953. Note the barren hillside in the background; today, it is covered with homes and tall trees. (Courtesy of Pleasantville Archives.)

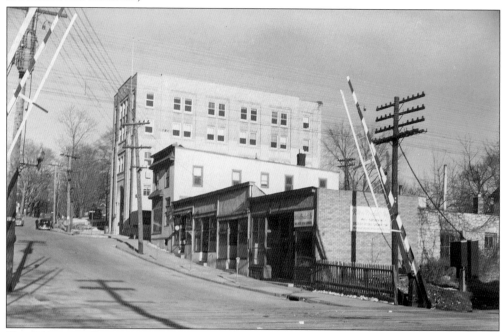

THE RAILROAD TRACKS. For years, Pleasantville leaders knew the railroad crossing on Bedford and Manville Roads was a safety issue for the growing community. Each time a train passed through the village, a crossing barrier had to be lowered and traffic came to a halt. (Courtesy of Pleasantville Archives.)

114

THE RAILROAD TRACKS. The long barriers that were lowered with each train coming into Pleasantville were also a thorn to local merchants who were a stone's throw away from the tracks. This view is of the railroad crossing on Bedford Road heading up to the old village. (Courtesy of Pleasantville Archives.)

RAILROAD TRACKS. Here is another look at the railroad track barriers on Bedford Road. Residents reported very long waits for trains to leave the station and the subsequent lifting of the track barriers. (Courtesy of Pleasantville Archives.)

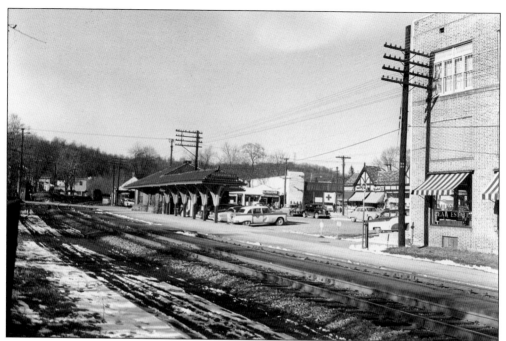

LOWERING THE TRACKS. The most significant event of the 1950s was the lowering of the railroad tracks and the elimination of the grade crossing at Bedford and Manville Roads. This photograph is of the old train station on Wheeler Avenue. (Courtesy of Pleasantville Archives.)

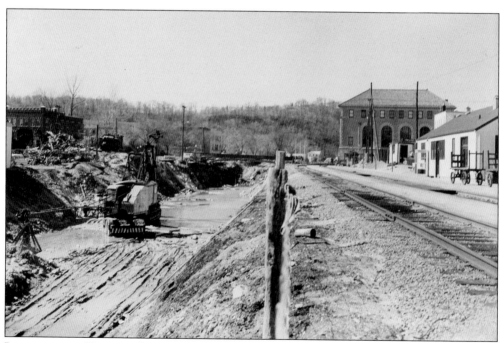

LOWERING THE TRACKS. The work to lower the tracks was massive. It required the demolition of several homes and stores. On the right in this construction photograph is the old Pleasantville freight station stop. The project was completed in 1961. (Courtesy of Pleasantville Archives.)

MOVEMENT OF STONE RAILROAD STATION. The original site of the stone Railroad Station was on Manville Road, as seen in this photograph. In April 1958, two trucks and nearly two dozen men worked nine hours moving the station approximately 60 yards to a temporary holding site on a lot behind 10 Washington Avenue. It was moved to its current location on Wheeler Avenue a few years later. Today, it is home of the highly rated Iron Horse Grill Restaurant. (Courtesy of Pleasantville Archives.)

TOWNSMAN. The *Townsman* was a popular Mount Pleasant publication in the 1950s. This November 22, 1951, issue highlights the 50th anniversary of the Daniel P. Hays Hose Fire Company. The company was organized by 14 residents of the Old Village in November 1901. (Courtesy of Dianne Ripley.)

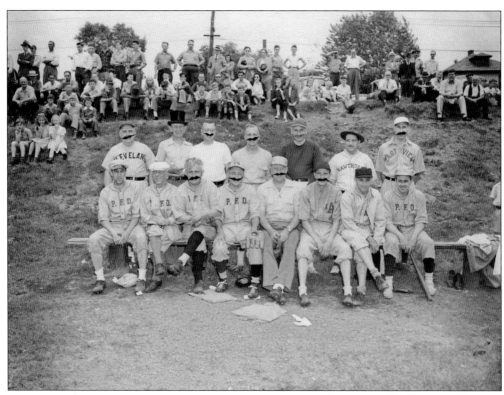

SOFTBALL. The Pleasantville Fire Department fielded a softball team to play a squad from Mount Pleasant. There was much fun to be had on and off the field as the fake mustaches indicate in this photograph taken around 1950. (Courtesy of Mount Pleasant Library.)

SOFTBALL. This photograph is of the Pleasantville All-Stars adult softball team playing the Yonkers All-Stars around 1950. The game was very well attended; fortunately the home team won, and a large celebration took place afterwards. (Courtesy of Mount Pleasant Library.)

NANNAHAGAN GOLF CLUB. An old postcard of the original Nannahagan Gold Club in Pleasantville is seen here. (Courtesy of Mount Pleasant Library.)

THE THORN BUILDING AND SUNSET HALL. The Thorn Building with Sunset Hall looming in the rear had more than 100 years of service on Wheeler Avenue. This May 23, 1941, photograph was taken one week before demolition. Sunset Hall was Pleasantville's site of religious services, community meetings, and the scene of all public entertainment for decades. (Courtesy of Pleasantville Archives.)

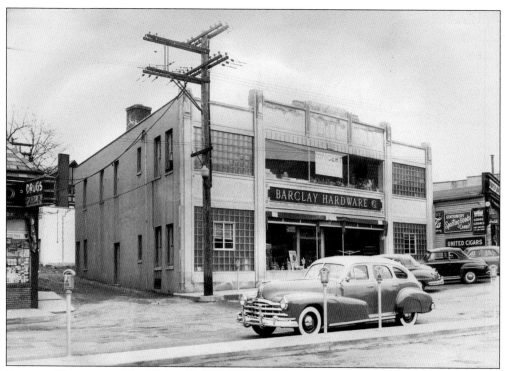

BARCLAY HARDWARE. The Thorn Building and Sunset Hall on Wheeler Avenue was replaced with this building, which was the home of Barclay Hardware for nearly 50 years. (Courtesy of Pleasantville Archives.)

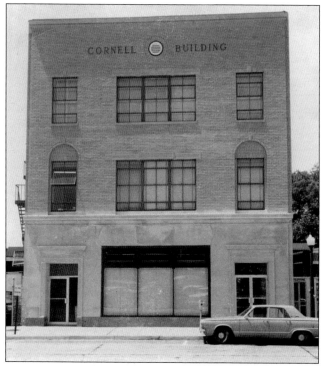

CORNELL BUILDING. This c. 1960 photograph is of the handsome Cornell Building on Memorial Plaza. (Courtesy of Pleasantville Archives.)

NEW 42 MEMORIAL PLAZA. A fire destroyed the handsome Cornell Building and it was replaced with this new building at 42 Memorial Plaza. The post office was built after the fire. Note the garage door in the 42 Memorial Plaza building that was used by Higham Press to facilitate massive *Reader's Digest* mailings. The building has a number of cosmetic changes and is now the site of Starbucks in Pleasantville. (Courtesy of Pleasantville Archives.)

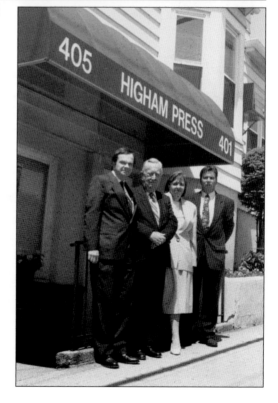

HIGHAM PRESS. The Higham Press building was on the corner of Manville Road and Grant Street. Higham Press had a strong strategic business relationship with *Reader's Digest* for nearly 50 years. This c. 1970 photograph has Fred G. Higham (left) next to his father, George H. Higham. (Courtesy of Fred Higham.)

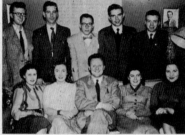

"I pledge allegiance to the Flag of the United States of America and to the republic for which it stands, one nation under God, indivisible, with liberty and justice for all."

OFFICIAL NEWSPAPER OF THE VILLAGE OF PLEASANTVILLE AND THE TOWN OF MOUNT PLEASANT

Pleasantville Journal

Only Newspaper Printed, Published in Pleasantville, serving an area of 25,000 in Pleasantville, Town of Mt. Pleasant, Chappaqua, Briarcliff

69TH YEAR — NO. 23 PLEASANTVILLE, NEW YORK, THURSDAY, MARCH 15, 1956 PRICE FIVE CENTS

Residents Vote For 2 Trustees, Tuesday, 2 To 9

Qualified voters will go to the polls next Tuesday between 2 p. m. and 9 p. m. to vote for two Village Trustees for two year terms each. Albert Ripley, (see editorial, page 2) has been nominated to succeed William Fennell. Edward Crapser was renominated.

Polling places are: for election district no. 1, Municipal Building; for election district no. 2, Hays Hose Firehouse.

RECENT BRIDE

DANCERS FROM IRELAND TO VISIT HERE

AINE McCOY, NIECE OF PATRICK McCOY of Washington Avenue, and her dancing troupe of Belfast, Ireland, who appeared last year on the Arthur Godfrey TV show, recently returned here. Tomorrow night, they will entertain at the St. Augustine Church in Ossining. After the show they will visit Mr. and Mrs. McCoy. Recent appearances in the United States include the Dave Garroway Show, Boston, Lynn, Cambridge and Hunter College. They are the

Group, Headed By J. Porcello, Form New Civic Association; Hold Meeting Next Monday

Those wishing to become charter members of a new civic association are invited to a meeting to be held Monday, March 19 at 8:15 p. m. in the Camilli building, 72 Cooley St. A charter containing the purposes and aims of the organization will be read.

Residents who rent, own or who have property, or whose legal address is in the Town of Mount Pleasant, are eligible, regardless of race, creed or national origin. Plans for the organization have been made at six recent meetings.

Its aims are: (1) to promote better understanding between citizens and local government;

(2) support honest and constructive public officials; (3) promote good social relationships in the community; (4) promote civic organizations and improvements; (5) to aid and advise upon request any member in social, economic and educational matters.

The interim committee organizing the group is comprised of Dr. Joseph Porcello, chairman; Vincent DeMaso, Thomas and Frank Figlia, Frank Rizzo, Sal Rubino and Frank Pataro.

AREA NEWLYWEDS

Red Cross Slates

ANNA McCOY. A March 15, 1956, *Pleasantville Journal* article featured the arrival of the Anna McCoy dancing troupe from Belfast, Ireland. Anna (white blouse) was the niece of Patrick McCoy of Washington Avenue and was often called "the Babe Ruth of Irish dancing." She was a legendary champion performer who most Irish dance experts credit with reinstating traditional Irish dance as an art form, and who inspired the 1994 creation of Riverdance, the world-renowned Irish dancing group. (Courtesy of Richard Patrick McCoy.)

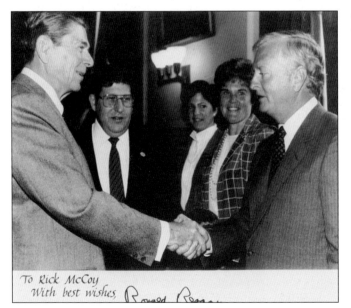

To Rick McCoy With best wishes, Ronald Reagan

RICHARD PATRICK McCOY. Richard ("Rick") Patrick McCoy rose to great heights after leaving Pleasantville. Here, he is in the White House in 1982 with his wife, Nancy, looking on as he shakes hands with Pres. Ronald Reagan. McCoy opened his first McDonald's Restaurant in 1966 in Salem, New Hampshire. When he sold out a few years ago after 38 years in the industry, he owned over 100 restaurants in the Northeast, ending his career as the largest McDonald's owner in the United States. (Courtesy of Richard Patrick McCoy.)

HARRY FOLEY. Harry Foley was a legendary athlete and businessman in Pleasantville. He was a Pleasantville High School All-County basketball player who went on to Niagra University, where he had great success and was inducted into the institution's sports hall of fame. He is also a member of the Westchester County Hall of Fame. Foley owned the Rail Bar and Restaurant for years before opening Foley's Club Lounge on Bedford Road in the late 1960s. (Courtesy of Jim Mustich.)

SIDEWALKS. One of the many wonderful features of Pleasantville is that it is truly a "walking community." Pleasantville had the first street lamps, the first bank, the first high school, and the first sidewalks in Mount Pleasant. (Courtesy of Pleasantville Archives.)

FANCHER NICOLL. Members of the Pleasantville Fancher Nicoll American Legion Post 77 annual chili fundraiser at Holy Innocents Social Hall are seen here. Founded in 1919, the post is one of the oldest in the United States and has a very long tradition of service in the village. (Courtesy of Roy Westmoreland.)

DAD'S CLUB YOUTH SPORTS. The Pleasantville Dad's Club youth recreations sports programs is a vibrant part of the village. For decades, parents volunteered time to teach and coach good sportsmanship. This 1997 photograph is of 10-year-old Jack Ruiz driving a pitch into the right-field gap for extra bases. Ruiz was on the only Dad's Club baseball travel team that played spring, summer, fall, and winter (indoor) baseball.

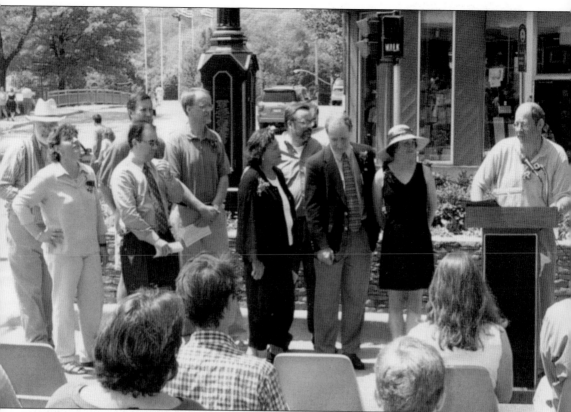

Clock. This is the May 15, 2004, dedication of the clock tower. At the podium is Pleasantville Mayor Bernie Gordon with a group of Pleasantville's best and brightest. (Courtesy of Peter Q. Eschweiler.)

LENNY JOYNER. Lenny Joyner, a graduate of Pleasantville High School, passed away on July 24, 2012. He was 31 years old. Joyner died in a tragic climbing accident coming down from the 14,156-foot South Maroon Peak summit in Aspen, Colorado. Joyner is seen in this photograph holding his newborn nephew, Christian. Lenny was a gift to Pleasantville— always helping and volunteering in a cheerful positive fashion. His passing was a great loss to the entire village.

LENNY JOYNER. Joyner served with the Pleasantville Fire Department for years and was a highly regarded New York City Fire Department paramedic. It is fitting that the last two photographs in this book honor a fine Pleasantville native who spent his short time on earth living the historic village tradition of charity.

BIBLIOGRAPHY

Bolton, Robert. *A History of the County of Westchester from its First Settlement to the Present Time.* 2 vols. New York: Alexander S. Gould, 1848.

———. *The History of Several Towns, Manors and Patents in the County of Westchester,* Edited by C.W. Bolton. 3rd ed., 2 vols. New York: J Cass, 1905.

Carmer, Bertram H. *Silver Anniversary: Mount Pleasant Bank and Trust Company.* Pleasantville, New York: privately published, 1929.

Corcoran, Dennis J., Martin S. Friedman, and Carsten Johnson. *Pleasantville 300 Years From Manor to Suburb, 1695–1995.* Pleasantville, NY: Higham Press, 1995.

Donovan, Daniel, and Carolyn Casey. *A Century of Education; Pleasantville 1826–193.,* Pleasantville, NY: Higham Press, 1997.

French, Alvah P. *History of Westchester County New York.* 5 vols. New York: Lewis Historical Publishing Company, 1925.

Horne, Philip Field. *Mount Pleasant: The History of a Suburb and Its People.* Hawthorne, NY: privately published, 1971.

Hufeland, Otto. *Westchester County during the American Revolution 1775–1783.* White Plains, NY: Westchester County Historical Society, 1926.

Kopper, Philip. *North American Indians Before the Coming of the European's.* Washington, DC: The Smithsonian Institution, 1986.

McAllister, John T. *Pleasantville Jubilee Program.* New York: Associated Printcraft, 1947.

Osterhoudt, Reginald. *Pleasantville; "All that the Name Implies."* Pleasantville, NY: privately published, 1942.

Scharf, J. Thomas. *History of Westchester County, New York, including Morrisania, Kings Bridge, and West Farms, which have been annexed to New York City.* 2 vols. Philadelphia: L.E. Preston and Company, 1886.

Struble, Mildred E. *Town of Mount Pleasant 1788–1988.* Mount Pleasant, NY: privately published, 1988.

Waterbury, George, Claudine Waterbury, and Bert Ruiz. *Images of America: Mount Pleasant.* Charleston, SC: Arcadia Publishing, 2009.

Wood, James Playsted. *Of Lasting Interest; The Story of the Reader's Digest.* Garden City, New York: Doubleday & Company, 1967.

DISCOVER THOUSANDS OF LOCAL HISTORY BOOKS
FEATURING MILLIONS OF VINTAGE IMAGES

Arcadia Publishing, the leading local history publisher in the United States, is committed to making history accessible and meaningful through publishing books that celebrate and preserve the heritage of America's people and places.

Find more books like this at
www.arcadiapublishing.com

Search for your hometown history, your old stomping grounds, and even your favorite sports team.

Consistent with our mission to preserve history on a local level, this book was printed in South Carolina on American-made paper and manufactured entirely in the United States. Products carrying the accredited Forest Stewardship Council (FSC) label are printed on 100 percent FSC-certified paper.

MADE IN THE